Institute of Contemporary Art Boston
Made in Mexico

Table of Contents

Jill Medvedow
James Sachs Plaut Director
Foreword

Long a source of creativity and experimentation for artists and intellectuals in the twentieth century, Mexico has had a profound influence on several generations of contemporary artists. *Made in Mexico* is the first exhibition to fully examine this influence through the work of a diverse group of international artists. Investigating the different ways in which artists express their views of Mexico, its history, and the way it is perceived by the rest of the world, *Made in Mexico* contrasts the work of the current generation of Mexican artists with that of artists from around the world to better understand the relationship between globalization and local identity.

Understanding the role of place in our increasingly mobile and interconnected society is one of the critical tasks of the changing millennium. *Made in Mexico* poses several questions about the balance between the particulars of local politics, customs, vernacular, and environment and the diverse composition of national and global identities, languages, economies, and currencies. We are witness to the fluidity of fashion, music, film, celebrity, and corporate branding all over the world. Contemporary art, as a subset of these global trends, allows us to see them through the lens of the individual artist and institution.

Mounting this exhibition required many months of research and study both in Mexico and in Boston. I am grateful to ICA Assistant Curator and exhibition organizer Gilbert Vicario for providing insight and expertise into this original thesis. He was assisted by the talented staff at the ICA, and we extend our gratitude to Registrar Nora Donnelly, Curatorial Assistant Emily Moore, and Exhibition Manager Tim Obetz for their able assistance in the production of the catalogue, the exhibition design, and the complex movement of objects and installations, as well as to Director of External Relations Paul Bessire and Communications Manager Melissa Kuronen for enabling us to bring this project to fruition.

We could not have mounted this ambitious exhibition without the generosity of our lenders and philanthropic partners. We are grateful for the assistance of each of our lenders: American Fine Arts, New York; Kenneth L. Freed; Jack Tilton Gallery, New York; La Colección Jumex, Mexico City; Rodrigo Peñafiel, Mexico City, Galería OMR, Mexico City; Matthew Marks Gallery, New York; Alexander and Bonin, New York; Museum of Contemporary Art, Chicago; Galería Enrique Guerrero, Mexico City; Luhring Augustine, New York; the Philadelphia Museum of Art; the Jack S. Blanton Museum of Art, University of Texas at Austin; Craig and Ivelin Robins, Miami Beach; Greene Naftali, New York; and Galerie Peter Kilchmann, Zurich.

We also extend our appreciation to Altria, the National Endowment for the Arts, La Colección Jumex in Mexico City, Kenneth L. Freed, and the Mexican Consulate in Boston/S.R.E. for their generous support, encouragement, and faith in this project.

We are especially pleased that UCLA Hammer Museum is joining us in presenting this exhibition and I thank Ann Philbin, Director and Russell Ferguson, Chief Curator for their enthusiasm and support. Finally, we are most grateful to the artists in *Made in Mexico*. We are delighted to welcome them and their art to the ICA and share the pleasures of intellectual and artistic pursuit with our audiences.

Altria Group
Foreword

The unbound creativity of contemporary art challenges us to view familiar worlds from new perspectives. *Made in Mexico* brilliantly does this by giving voice to a diverse group of contemporary artists that bring a fresh point of view to Mexico's profound influence as a source of creativity, ingenuity and experimentation.

As we have seen in our sponsorship of cultural organizations for more than forty-five years, the arts have a unique power to build bridges between people and cultures, while inspiring us to envision new possibilities. In this spirit, we are proud to sponsor *Made in Mexico*, a ground-breaking exhibition of twenty international artists expressing their wide-ranging views on Mexican history, folklore, popular iconography, politics and culture.

The Altria family of companies salutes the Institute of Contemporary Art for gathering these imaginative works, which use media as diverse as sculpture, film and soap bubbles to articulate provocative ideas. We hope you will be inspired by this opportunity to contrast the recent work of Mexican artists with artists from around the world who have come to discover that inspiration is made in Mexico.

Jennifer Goodale
Vice President, Contributions

 Altria

Gilbert Vicario

What Makes Art Mexican?

"Made in Mexico" is a phrase that in the minds of many people is synonymous with inferior quality or artistry. Through this provocative phrase, *Made in Mexico* draws together a disparate group of artists under the umbrella of a national framework at a moment when larger, socio-political, and economic powers are breaking down borders between countries and cultures. While the exhibition draws attention to the "making" of art, it is not only concerned with issues pertaining to local materials but refers to aesthetic labor — mental and physical — wrought under the conditions found within a particular economy. *Made in Mexico* draws attention to artistic production, but in clear relation to how those ideas inform both local and international artists. In thinking of Mexico in relation to globalism, or of a first world artist choosing to work in a third world context, it becomes clear that the distinctions between cultural territories are becoming more and more difficult to grasp. In other words, to say that a European artist working in Mexico is merely a cultural tourist is as problematic as saying that a Mexican artist adopting a conceptual vocabulary is simply being derivative of a prevailing European or North American trend.

Made in Mexico presents the work of the Mexican artists Eduardo Abaroa, Claudia Fernández, Teresa Margolles, Gabriel Orozco, Damián Ortega, Pedro Reyes, Sebastián Romo, and Daniela Rossell along with long time resident artists Francis Alÿs, Thomas Glassford, Santiago Sierra, and Melanie Smith. Establishing a larger dialogue, *Made in Mexico* also includes the work of non-resident artists — Andrea Fraser, Erik Göngrich, Terence Gower, Andreas Gursky, Mona Hatoum, Sharon Lockhart, Yasumasa Morimura, Anton Vidokle — whose work does not necessarily come out of a local experience yet draws upon a distinctly Mexican vernacular, whether iconographic, architectural, or environmental.

For most artists coming from Europe or the U.S., being able to live and work in Mexico has enabled them to examine their own backgrounds, liberating them from their national burdens while being forced to grapple with the political and cultural specificities of Mexico. Aside from its essential lure as a multilayered culture combining pre-Columbian, European, and contemporary art and architecture, Mexico in recent years has created a narrative about its ability to survive despite the severe economic hardship felt by most of its citizens. Widespread corruption, increased drug trafficking, and the continued devaluation of the peso have enabled a significant body of work to emerge out of what has been termed the "aesthetics of corruption." Artists from both Mexico and abroad interested in the essential characteristics of Mexican identity still abound, invoking fundamental (and some would say clichéd) aspects of Mexican art such as death, muralism, archaeology, and Frida Kahlo. Younger artists are increasingly investigating Mexico's relationship to European modernism and abstraction. Inspired by midcentury architectural programs, many of these investigations combine aspects of Bauhaus-inspired design philosophies with the work of local architects. Everyday materials have also inspired many artists, creating a dialogue around common themes and vernacular details found within the urban landscape.

The image of Mexico as an independent nation with its own intrinsic philosophies and aesthetics was first shaped by José Vasconcelos, Minister of Education in the early 1920s. As Minister of Education, Vasconcelos developed an architectural program that paired neocolonial building projects with commissioned murals by artists such as Diego Rivera and David Alfaro Siquierios.[1] Concurrent with these internal developments were many overtly political attempts to promote Mexican culture and a nationalist aesthetic abroad. According to art historian and curator Olivier Debroise, in late 1921 Katherine Anne Porter, the American writer and journalist, was asked to organize an exhibition of Mexican art and send it abroad as a way of promoting the country's cultural development.[2] As Debroise explains, "Porter's project was accepted because it fit with the Mexican government's desire for diplomatic recognition." Porter, who had never curated an exhibition, had numerous assistants including the noted archaeologist Manuel Gamio and the artists Miguel Covarrubias, Carlos Mérida, and Diego Rivera. The exhibition and accompanying catalog titled Outline of Mexican Popular Art were not easy to sell, as the U.S. government refused to cooperate on the basis of the exhibition's perceived political propaganda. "Porter's show was the first significant survey of Mexican art ever presented abroad," said Debroise, "and, as such, it set the course for exhibitions of Mexican art abroad and would be repeated, with few conceptual changes, many times over the following 70 years."[3] As contemporary artists become increasingly suspicious of exhibition frameworks heavily dependent on nationalism, so does their awareness of the relative value of context and placement. In recent years, several artists dealing with ideas of Mexicanismo have begun to challenge long-held assumptions about nationalism, authenticity, and political correctness.

Gabriel Orozco's approach, incorporating the production of sculpture within multiple national contexts, has demonstrated an ability to refer to his Mexican background in subtle and conceptually detached ways. In Black Kites, 1997, he covered a human skull in a visually arresting yet delicately handled checkerboard pattern. For Orozco, the checkerboard pattern represented the analytic mapping of consciousness, both positive and negative, onto the surface, while alluding to the Duchampian tradition of gamesmanship. More than any previous work, Black Kites inevitably played into the hands of those intent on identifying the artist with a specifically Mexican artistic tradition. While comparisons to the indigenous Mexican tradition of El día de los muertos (Day of the Dead) sugar skulls are inescapable, the artist's disavowal of such connections can be appreciated not so much as a rejection of cultural stereotyping, but as an expression of individualism detached from a nationalist agenda. In a subsequent project for the Philadelphia Museum of Art entitled Photogravity, 1999, Orozco initiated a sculptural dialogue between photographic reproductions of his better-known sculptural works and photographic reproductions of pre-Columbian sculpture from the museum's Louise and Walter Arensberg Collection.[4] For Orozco, this juxtaposition allowed him to continue his conceptual investigation into sculpture, gravity, and weight while fusing together different instances of the presentation of Mexican art and its appearance within museum collections.

1. See Valerie Fraser, Building the New World: Studies in the Modern Architecture of Latin America, 1930-1960, (London: Verso, 2000).

2. Between the years 1918 and 1921 Katherine Anne Porter became involved in revolutionary politics in Mexico, the scene of several of her stories, where she worked as a journalist and teacher. Mexico, Porter once said, gave her back her Texas past. Her feelings toward Mexico, however, were ambivalent in such later works as "Xochimilco." Porter saw Mexico as an earthly Eden where hopes for a better society could be realized, while in other stories, including "The Fiesta of Guadalupe," she depicts Mexico as a place of hopeless oppression for the native peoples.

3. Olivier Debroise, "Mexican Art on Display," in The Effects of the Nation: Mexican Art in the Age of Globalization, ed. by Carl Good and John V. Waldron, (Philadelphia, PA: Temple University Press, 2001), p. 26.

4. Nelson Rockefeller introduced Mexican and pre-Columbian art to the Arensbergs, who bequeathed their collection to the Philadelphia Museum of Art in 1952. The first installation of their collection at the museum was overseen by Marcel Duchamp, who installed many fine examples of pre-Columbian objects such as ball court rings alongside early modernist masterpieces including works by Duchamp himself.

For over a decade, Teresa Margolles has embraced the ever-present Mexican theme of death. Rather than playing off the folkloric traditions associated with it, she instead tackles the increasing violence and death that affects people on a daily basis. Beginning in the early 1990s, Margolles, along with an artist collective whose name SEMEFO (Servicio Médico Forense, "the Forensic Medical Service"), was appropriated from the actual state agency that manages the transfer of unclaimed bodies to the country's many morgues, began to produce works exploring the aesthetics of death and what the collective has termed "the life of the corpse." Much of SEMEFO's work dwelt specifically on the increased level of violence in both the capital and the northern cities that harbor the country's drug trade. The use of corpses, both human and animal, has been a singular and identifying attribute of the artistic collective in their role as pathologists and morticians of a dysfunctional social fabric.

5. Critical regionalism seeks to recognize architectural traditions that are intimately rooted in and evolving from local conditions, but nevertheless point the way to a highly evolved and intelligent modern architecture. Most prominently theorized by the contemporary architectural historian Kenneth Frampton, critical regionalism understands culture "not as something given and relatively immutable but rather as something that has, at least today, to be self-consciously cultivated."

6. Edward Said, "The Art of Displacement: Mona Hatoum's Logic of Irreconcilables," in Mona Hatoum: The Entire World as a Foreign Land, exhibition catalog (Tate Britain, 23 March – 23 July 2000), p. 15.

As a solo artist, Margolles has continued to produce work with the assistance of the real SEMEFO morgue. This has enabled her to continue to address the relationship between abject poverty and the blackmarket economy of the drug trade. For Margolles, the morgue becomes a social barometer measuring desperation and violence by the number of unclaimed corpses at any given time. In 2000, Margolles created one of her most disturbing works of art, involving the dissection and embalming of a human tongue and its subsequent exhibition at ACE gallery in Los Angeles. The tongue belonged to a young man who had died in a drug-related fight. The family of the victim could not afford to bury their son, and Margolles offered to pay for a proper burial in exchange for this organ. Most recently, Margolles has gained international attention for more minimalist installations featuring water collected from the morgue. En el air (In the Air), 2003, an installation of bubble machines filled with a combination of soap and water collected from the morgue, becomes an elegiac memorial to the lives of individuals forgotten within a crumbling social and economic infrastructure.

Sharon Lockhart's photographic project in Mexico explores the relationship between cultural patrimony, colonialism, and ethnicity realized at the National Museum of Anthropology in Mexico City. The series, comprised of nine photographs of empty galleries at the anthropology museum and three focused on a masonry worker, captures the austerity and cool minimalism of the interior spaces. Designed in 1963 by the Mexican architect Pedro Ramírez Vásquez, the clean, elegant aesthetic of the museum's architecture contrasts with the pre-Columbian objects on display (approximating what Kenneth Frampton has termed "critical regionalism").[5] In the triptych Enrique Nava Enedina: Oaxaca Exhibit Hall, National Museum of Anthropology, Mexico City, 1999, a Mexican mason replacing tiles in one of the galleries is gradually enclosed by the glass partitions that he uses to protect the surrounding objects from dust. Lockhart's camera captures a layered tableau that collapses temporal distances and multiple socioeconomic realms within a small sequence of images. Far from being pure documentation or cinematic staging, the triptych becomes a metaphor for the construction of meaning and history within the museum. Enrique Nava Enedina's gaze back into the camera engages the spectator in a self-reflexive process that underscores the over-determined politics of looking and display and the relationship between cultural tourism and national patrimony.

Making work in Mexico has enabled Mona Hatoum to explore issues of context and place from a paradoxically detached yet highly subjective perspective. Edward Said wrote, "An abiding locale is no longer necessary in the world of Mona Hatoum's art...familiarity and strangeness are locked together in the oddest way, adjacent and irreconcilable at the same time."[6] As Hatoum's recent production of work in Mexico attests, familiarity and strangeness do appear to have a symbiotic

dynamic, but more importantly reinforce several universal truths pertaining to economically and politically subservient nations. *El pájaro de la suerte (Fortune Telling Bird)*, 2002 - 2003, represents Hatoum's video documentation of a popular street performance involving "Dandy," a small canary that reads fortunes and performs a series of circus acts – placing a miniature hat on a doll, ringing a bell, laying a plastic baby in a tub – all for a few grains of birdseed. As Hatoum explains, despite the cuteness and cleverness of the bird one cannot help drawing a parallel between the useless routine activities that Dandy performs for a few seeds and the more serious implications of conditioned reflex, menial factory work, and other alienating forms of labor. In *La jaula mexicana (The Mexican Cage)*, 2002, Hatoum's human-sized version of the canary cage, the societal implications of repetition and subservience inscribe a much darker, ongoing dialogue on the metaphor of the feminine body, domesticity, and incarceration that is intrinsically bound to her vocabulary of forms. Although initially jarring for those accustomed to her usually neutral palette, the work enters into a dialogue with Mexico using bright, primary colors intended to replicate the original source. By contrast, the radial form of *Pom Pom City*, 2002, created out of natural wool from artisanal weavers in Teotitlán del Valle, Oaxaca, focuses on Mexico City and the representation of the colonial grid along with long, curving strands representing hundreds of years of chaotic growth.

Perhaps no greater popular icon exists in the history of twentieth-century art than Frida Kahlo. Although her work is marginal in relation to surrealist artists of the period, Kahlo's biography and iconography have become a source of interest since her rediscovery in the early 1970s by the art historian and critic Raquel Tibol. Yasumasa Morimura's own discovery of Frida Kahlo has resulted in the recently completed series *An Inner Dialogue with Frida Kahlo*, 2001. Although Morimura has never traveled to Mexico, his preoccupation with the Mexican artist has engaged him in an indirect dialogue with Mexico for over 10 years. Widely known for his transgendered transformations, Morimura has drawn on Kahlo to make extremely perceptive statements on the connections and coincidences between traditional Mexican and Japanese styles of dressing and adornment. Morimura has described Kahlo's art as a "fierce and intense manifestation of human sentiments and universal themes," and his ability to recreate iconic works such as *Self-Portrait with Monkey*, 1938, *Self-Portrait as a Tehuana (Diego on my Mind)*, 1943, and *Self-Portrait with Braids*, 1941, continues his fascination with canonical images of art history. In Morimura's version, the theatrical details used to construct Kahlo's paintings are discernible and lend an air of kitsch extravagance to the photos, while his expressions remain serious and touchingly sincere. The details he uses are very important in their ability to convey an emotional tactility to the images, and in some cases humorously reference contemporary consumer culture. In Morimura's photograph titled *An Inner Dialogue with Frida Kahlo (Hand-Shaped Earring)*, 2001, he uses a Louis Vuitton shawl in place of one of the more typically Mexican rebozos that Kahlo was known for wearing, suggesting the contemporary obsession with status symbols.

The relationships between art and politics are central to Andrea Fraser's artistic project. Fraser, a conceptual artist who has developed a critique of museums, has been especially interested in the underlying and sometimes hidden motivations of patronage. She recently completed a video installation entitled *Soldadera (Scenes from Un Banquete en Tetlapayac, a film by Olivier Debroise)*, 1998/2002. *Un Banquete en Tetlapayac* was an experimental film made in 1998 exploring the circumstances surrounding the creation of Eisenstein's legendary film *Que Viva Mexico!* Appropriating several parts of the film, Fraser played dual roles as a peasant revolutionary and as Frances Flynn Paine, an arts patron, who allegedly urged Abby Aldrich Rockefeller to support Diego Rivera, Frida Kahlo, and Tina Modotti. Fraser's text in her video comes from a letter dated 1930 in which Paine urged Rockefeller to support Mexican artists. In Fraser's appropriated film stock, beautiful images of the Mexican landscape — replete with volcanic mountains and agave plants — is intercut with allegorical images of some of Mexico's most famous revolutionary artists, including Fraser as a peasant on horseback waving a large red flag. Mixing fact with fiction, Fraser's project collapses seven decades of Institutional Revolutionary Party (PRI) rule, in which the party had almost total control over the economic, social, and cultural life of Mexico, as a critique of current cultural politics. As writer and artist Barbara Pollack has noted, "In Fraser's worldview, Rockefeller's support, politically inspired in part, for Mexican modernism was a precursor of contemporary cultural globalism."[7]

7. Barbara Pollack, "Baring the Truth," Art in America, No. 7 (July 2002), pp. 86, 87.

8. Joshua Decter, Anton Vidokle: Popular Geometries, Trans Publications, 2001.

In recent years, contemporary artists have been increasingly interested in the utopian aspirations of modernism, and their work has begun to reflect both their skepticism and admiration of these seemingly universal ideologies. Approaching from the perspectives of architecture, abstraction, and the wholesale rejection of nationalist iconography, these artists have begun to create work that straddles the line between design and decoration, as well as between patriotism and utopia. Anton Vidokle, a Russian-born, New York-based artist occasionally produces work in Latin America as a way of addressing his own relationship to modernism through an understanding of Russian and Soviet art making. In 2000, he began investigating these issues during an extended stay in Colombia where he discovered a cottage industry creating hand-woven, utilitarian objects such as handbags out of discarded plastic materials found on international shipping cartons. This led Vidokle to create minimalist cube structures out of the same pieces of plastic strips in patterns that evoked Bauhaus textile design, thereby assimilating and conflating various cultural, historical, and aesthetic references. The following year he turned his attention to Mexico City, where he became fascinated with the social uses of modernist abstraction within Mexican society. In a series of sculptures, paintings, and rugs created in 2001, Vidokle referenced private and corporate logotypes, printed matter, architecture, and public sculpture produced in Mexico City during the 1970s and early 1980s.[8] In Vidokle's work, design can inscribe the same utopian, progressive aspirations as architecture.

The following year Vidokle turned his attention to a badly neglected building he encountered in the historic center of the city, owned by the Mexico City Collective Transportation System (Sistema de Transporte Colectivo). The New York-based environmental graphic designer Lance Wyman, who designed the graphic identity of the 1968 Olympic Games in Mexico and the pictographic system used in the Mexico City subway system, had influenced the design of this building. Intrigued by the super-futurist design of the modular windows, Vidokle produced a series of paintings and, with sound artist Christian Manzutto created a film that decontextualized the building's façade and returned it, albeit briefly, to its original, pristine appearance. In the summer of 2003, Vidokle embarked on a collaborative art project with Sala Siqueiros in Mexico City that revisits the building. His film Nuevo, 2003, focuses on the repainting performance that

took place on August 4 – 15, 2003, with the assistance of the transportation system authorities. Vidokle's interest in repainting the building red, a color most often associated with socialism, stemmed in part from his interest in muralism as a utopian project caught between nationalism and progressive international design.

The Canadian artist Terence Gower addresses the architecture of pavilions, exhibitions, and museums as a way of analyzing the relationship between display and function. In a recent site-specific project entitled *El Pabellón Jumex*, 2002, inspired by Mies van der Rohe's nonfunctional concept of display structures, Gower designed a sculptural object with a functional purpose — storage for bicycles belonging to the factory workers at the juice-manufacturing plant Jumex. Gower's project appropriates Mies's use of the photomural as an exhibition device. *Functionalism*, 2003, consists of photographic documents of several examples of Mexican functionalist architecture. These black-and-white photographs capture the buildings in the year of their construction, freezing them as ideal images. Alongside these architectural images, Gower incorporates a hand-painted reproduction of a New Yorker cartoon from the 1930s in which two women discuss casually tossing a sombrero into a living room in order to make it look more Mexican. In *Functionalism*, quaint notions about Mexicanism from a North American perspective collide with internal architectural projects designed to present a sophisticated and progressive view of Mexico to the world. In Gower's installation, the photographs are themselves put on display using an exhibition technique developed by the same architects that influenced the design of the buildings depicted.

The Mexican artist and curator Pedro Reyes has been preoccupied with the relationship between art, architecture, and exhibition display for several years now. In 1998, Reyes began inviting artists to create site-specific installations inside the Torre de los Vientos monument designed and built by the Uruguayan sculptor Gonzalo Fonseca for the 1968 Olympics. Recently, Reyes has been focusing on his own artistic practice combining a steadfast interest in architectural anomalies, the urban landscape, and the utopian potential of industrial design. Recent projects have focused on a taxonomy of architectural tropes organized under a rubric similar to the periodic table of the elements. Using a simple axonometric rotation, Reyes has been able to create numerous forms or "prototypes" that in turn create sculptural objects. The objects themselves reflect the cultural and economic conditions under which they are produced, using inexpensive local materials and labor. His *Capulas* or cocoon-like forms are produced out of simply constructed iron structures covered in colorful plastic fibers that are most commonly used to create outdoor furniture. His project for the 2003 Venice Biennale entitled *Vertebras/The chair as an extension of the backbone*, 2003, consisted of series of modular fiberglass forms that function as both seats and tabletops. Drawing on a variety of modernist sources including Frederick Kiesler's midcentury designs, Reyes's functionalist furniture resonates with a desire to fuse form and function with economies of production and local specificities.

Aside from investigations into architecture, many artists have been actively involved in the exploration of abstraction within Mexico, which, unlike Venezuela or Brazil, has not had a consistent tradition of abstraction. Mathias Goeritz was a strong proponent of geometric abstraction, but in recent decades abstraction has been mainly confined to monumental, government-subsidized public art projects that typically appear in front of state houses or large hotel chains. In the last decade, investigations into abstraction have continued to be realized by expatriate artists living in Mexico. British-born artist Melanie Smith has been interested in the question of the viability of abstraction within the economic and social landscape of Mexico City. In an early project, Smith

focused on the color orange as a symbol of institutionalism and began to document this in a series of large-format photographs. In a related project, she created a series of paintings consisting of an assemblage of materials — knick-knacks, fabrics, and inexpensive molded plastics — all in the same orange hue. Other photographic projects have investigated abstraction found within the densely layered interiors of large, discount retail stores as well as small, independently owned shops. Smith's *Spiral City Project*, 2002, took Robert Smithson's *Spiral Jetty* as the inspiration for a video portrait of Mexico City. Shot from a helicopter that climbs circuitously upward, the video reveals the beauty and horror, abstraction and representation of the enormous urban sprawl of the city. In one of Smith's most recent installations, Installation of Paintings (variation) *Six Steps to Abstraction*, 2002, several abstract paintings are displayed in relation to two videos. The first video documents a conversation between a shop owner and a man wanting to reupholster a chair, while the other video documents a performance in which two men create a flat plane in a room using brightly colored string. For Smith, the videos become a metaphor for the many intellectual and formal desicions that go into the making of abstract painting while grounding them in a lived reality fraught with linguistic, political, and socially-inscribed negotiations.

Thomas Glassford, who was born in Laredo, Texas, and has worked in Mexico City for over a decade, has produced a variety of sculpture and mixed media objects using local materials. In the early 1990s, Glassford's sculpture was heavily influenced by the bottle gourd, an organic vessel that in Mexico is both an everyday object and artifact. Most of the works he made consisted of installations and towering sculptures that combined the gourds with hardware and odd, metal armatures that seemed to draw out a wide range of natural and socially inscribed allusions to sexuality, gender, and bondage equipment. In the last few years, Glassford has been using industrial designer products like aluminum profiles and neon tubes as materials for painting and sculpture. Glassford's work references American minimalism but makes less of an attempt to hide its relationship to design and decoration. In the series of paintings entitled *Partituras* (Partitions), Glassford takes aluminum panels that are used to make garage doors and places them side by side to create elegant, rippled patterns. The flat density of the aluminum, as well as the muted colors, seem to absorb light rather than reflect it, enabling one to focus on the rhythmic patterns and subtle ribbings inherent to the industrially manufactured material. Simultaneous to the *Partituras* series, is the *Aster* series, begun in 2001 and first exhibited inside the Torre de los Vientos monument. The *Aster* series is related to a very popular geometric form easily read within multiple cultural and social contexts. The basic form of the aster, which resembles an exploded firecracker frozen in space, is comprised of an arrangement of fluorescent tubes organized concentrically around a sphere. The fluorescent tube, most commonly used in industrial applications for its relatively inexpensive operating cost, is also more commonly used in Mexico by individuals in domestic spaces for those same reasons. In Glassford's series, social and political considerations of materials mesh with vernacular interpretations of abstract formalism.

For the current generation of artists in Mexico and elsewhere, ideas of the urban landscape, social realities, and conceptualist photographic strategies would have been impossible without the historical precedent of earlier artists such as Daniel Buren or Robert Smithson. In such current works, fundamental principles of context informed by postindustrial societies become absorbed and critiqued from within a society that constantly ricochets between a first- and third-world reality. Within the context of globalism, for many of the artists working in and learning from Mexico, conceptualism has enabled political and aesthetic issues to merge, thus creating a dialectical space never before witnessed in the history of Mexican art. The work of the Mexican

artist Damián Ortega for example, plays with a desire to understand economies of production within the socioeconomic territory of Mexico. In a recent project exhibited at the University of Pennsylvania's ICA entitled *Cosmic Thing*, a gray Volkswagen Beetle is completely disassembled and displayed like an exploded diagram. The largest manufacturing plant in Mexico belongs to Volkswagen, where the Beetle has been in production since 1967, at the rate of hundreds of cars a day. For Ortega, the ubiquitous automobile signifies among other things democracy, economy, and industrialization. *Adentro/afuera (Superficie modulada) [Inside/Outside (Modulated Surface)]*, 2002, is a sculpture originally designed by the architect María Elena Reyes Canseco. Sheets of acrylic and fiberglass are cut into a complex interlocking system of hinged flaps and doors, while a series of lines marked out in white tape on the floor suggests a working diagram or schema. As the title suggests, Ortega's sculptural maquette can be read as an exercise in the delineation of space via economical means. Also highly suggestive of notions of site-specificity as articulated in the 1960s, the work takes on a particular site-specific dependence on the current socioeconomic landscape of Mexico that has informed its making.

This interest in production and manufacturing is echoed in the work of the conceptually based sculptor Eduardo Abaroa. Known for creating work that uses materials and subject matter of the everyday, Abaroa constantly plays with notions of high and low culture. Influenced by television and consumerism combined with childhood and adolescent experience, Abaroa creates adult toys, vending machines with prizes, epoxy figures, and plants. This combination of toy store aesthetics, infantile naïveté, and moral anguish constitutes a commentary on mass production and the myriad ways in which it pervades the social and psychological unconscious. As part of the collaborative team Calimocho Styles, with Rubén Ortiz Torres, Abaroa has continued to explore fast-food culture and the relationships it creates between the U.S. and Mexico. One of their most successful collaborations has been in the production of colorful resin casts of half-eaten grilled corn on a stick, a ubiquitous street food in Mexico that can also be purchased anywhere from outside Catholic churches in southern California to neighborhoods in Queens, New York. In Abaroa's sculpture *Ancients vs. Moderns*, 2002, yellow Hostess cupcakes cover a mastodon's exterior, conflating consumption with a symbol of extinction. In an untitled series from 2002, Abaroa uses plastic drinking straws to construct organic structures evoking coral reefs and other microbiological systems.

Sebastián Romo, who was born in Mexico City and studied photography and documentary filmmaking, finds inspiration in land art and landscape interventions from the 1960s and 1970s. Recently he has begun investigating the relationship between photographs and sculptures in works that address different notions of time — mechanical and chemical time, condensation, elasticity — and diverse "species" of space, from private and interior to geographical and histori-cal. Romo's interest in tautologies of space and the artificiality of constructed space has led him to create architectural models that are "sited" within the space they are meant to represent. Using only museum board and glue, the scale models, usually around 1 inch = 5 feet, faithfully describe the intricacies of the interior spaces. In some cases, the scale models morph from a previous location to their present site, in an intriguing play on Smithson's notion of entropic movement, and carry with them the physical evidence of their prior embodiment. In addition to the art histori-cal references to site and non-site, Romo's work plays with the notion of geographic identification both through the neutrality of his chosen materials and the subjectivity of language. In 2002, Romo created a scale model of lower Manhattan post-9/11, in which the urban landscape and language are conflated in blocks of phrases that depict specific buildings. Recently he created a model of the urban landscape of Mexico City. *Límite*, 2003, serves as a metaphor for Romo's

own conflicted feeling about returning to Mexico after a long absence. Here the phrases chosen to represent the buildings were taken from taxi drivers, collectors, intellectuals, friends, curators, and domestic workers who were asked to describe Mexico City in their own words.

The many cultural layers embedded within the urban landscape inspire the Belgian-born artist Francis Alÿs. In 1991, Alÿs created his *Paseos* or *Walks*, a meditative, highly introverted form of performance art in which he walked through the city streets dragging a little magnetic dog mounted on wheels, literally attracting the urban residue found along its way. Alÿs has used his walks through a variety of diverse locales as a way of inscribing the relationship between the artist and his urban environment. Concurrent with his performance-based projects were a series of collaborations with local Mexican sign painters, or rotulistas. For Alÿs, the painting project was a way to attempt to illustrate existential situations he confronted, provoked, or performed on a public, urban, and ephemeral level, through the very literal technology of figurative painting and drawing. The process involved Alÿs asking a sign painter to reproduce an image by enlarging and multiplying the original. For Alÿs this procedure was an open-ended invitation for the sign painter to engage in an individual process of questioning and improving the image's power of communication. For Alÿs, this was not simply an exercise in authenticity and reproduction but ultimately an enterprise that quickly turned into a cooperative of painters producing hundreds of images over a period of four years. The content of the paintings served as a counterpoint to the walking projects yet reflected the social and economic environment of Mexico City in a similar way. For the artist, it is clear that his interest in figurative painting serves a broader purpose through its accessibility to a larger audience: "[figurative painting] can be used as a means to limit (and sometimes hopefully bridge) the actual gap existing between a general public and a more elitist contemporary art scene, without denying or diminishing the eventual contemporaneity of the content. I hope."[9] In this work as in his others, there exists a tension between the underlying concepts of the work and the subtle tradeoffs between his national identity as a Belgian and its formal and conceptual residue that commingles with local characters and local characteristics found within his daily life.

The use of photography as documentation presents itself in the work of Erik Göngrich, Andreas Gursky, Daniela Rossell, and Claudia Fernández. In 2000, the Berlin-based artist Erik Göngrich embarked on a three-month exploration of Buenos Aires, Bogotá, and Mexico City, and the ways in which their inhabitants move through them. For this project entitled *Sentado en el extranjero (Sitting Abroad)*, Göngrich enlisted the help of fellow artists, architects, and urban planners and created a questionnaire that asked respondents how they moved through their environments. Having witnessed the reunification of East and West Berlin and the subsequent architectural projects that have transformed the urban landscape, Göngrich has created work that deals with issues of urban space and collective memory. His venture into Latin America, which was his first exposure to these cities, called for a systematic methodology that could satisfy his curiosity about this new terrain without falling into the trap of merely being a cultural tourist. Göngrich's process systematically involved the photo-documentation of each city, a mix of architectural curiosities and specific urban intersections. The celebrated German photographer Andreas Gursky, on the other hand, recently traveled to Mexico and produced a single image from his trip. He went to various locales in and around Mexico City and in the end, *Untitled XIII (Mexico)*, 2002, an image of a dump outside the city limits, was realized. Some may criticize the image as one more negative representation of a nation consumed by its waste although the image resonates less as a representation of an entire nation than as a "non-site" — potentially representing consumption and waste as a universal condition.

9. Gianni Romano, "Francis Alÿs. Streets and Gallery Walks," in Flash Art vol. 33, no. 211 (March - April, 2000), p 70-73.

The power of photography has probably never been as well served as in the hands of the Mexican artist Daniela Rossell. Mexican bourgeois culture is an endless fascination to Rossell, and for several years has enabled the world to see into a sequestered, unimaginably decadent world of female domestic space. As a member of the upper ranks of Mexican society, Rossell was easily able to convince some of the wealthiest women in Mexico City, Monterrey, New York, and San Antonio to be photographed in their favorite rooms. In fact, she has created an enormously revealing photo archive that documents her extended personal network of family and friends. Titled *Ricas y famosas (Rich and Famous)*, this mordant yet highly amusing collection of photographs, begun in 1998, highlights the baroque sense of adornment with which these women carry themselves, the pretensions of the supposedly upper-class, and the conflicted, Eurocentric caste system which still dictates the social, economic, and intellectual status of its citizens. In her recent series, *Third World Blondes Have More Money*, 2002, Rossell continues to break down the divisions between society portraiture, fashion photography, and ethnographic photography through a perverse fascination with her subjects and the ways in which their sense of self becomes exemplified within their domestic surroundings. By contrast, Claudia Fernández investigates how domesticity becomes projected in social space in a series of photographs entitled La belleza oculta en *la propiedad ajena (The Hidden Beauty in Someone Else's Property)*, 2000. Fernández walked around several upper-middle class neighborhoods in Mexico City in a quasi-archaeological photo-investigation into how vernacular styles and ubiquitous materials are used to create a barrier between homes and the street. There are notable grids over doors and windows as well as fences and blinds ensuring inner privacy. For Fernández, what started out as a typological inquiry into form and function has become a fascinating meditation on the increasingly introverted and sheltered lives of its citizens.

The work of the Spanish artist Santiago Sierra deals with the confrontation of harsh socioeconomic realities and high art. Sierra, like many foreigners when they first arrive in Mexico City, witnessed intense social contradictions coupled with massive urban and human density. In the historic center, where he first lived, one is confronted with an astonishing cross section of pre-Columbian, colonial, and modern architecture, wealth and poverty, European and indigenous culture unlike anywhere else in the world. Sierra's work confronts the spectator with an abject situation born out of the realities of social inequality, exploitation of poorly paid workers, and the mixing of members of different social classes within the seemingly neutral yet highly segregated spaces of Mexico's art world. One of the main sources of controversy in his work stems from his use of people who are asked to participate in his installations in return for monetary compensation. In past actions, Sierra has hired laborers to perform fruitless tasks such as pushing enormous cement blocks around a gallery or to sit inside a cardboard box for the duration of a workday. In more controversial pieces, Sierra remunerated individuals for allowing him to tattoo a single line across their backs or for masturbating in the gallery.

Although Sierra's work has evolved in direct response to social conditions witnessed in Mexico City, many of his subsequent projects have been deployed in various national and international locales. In recent years, his use of hired participants has been repeatedly used to justify a current myth about contemporary Mexican society, but as Coco Fusco has pointed out, Sierra is not the first artist to incorporate human beings in works of art that comment on the relative value of human labor.[10] In a piece filmed in Chiapas, home to Subcomandante Marcos and one of the richest Mayan archaeological regions, Sierra paid 11 elderly indigenous women who do not speak Spanish to say, "I am being paid to say something the meaning of which I do not know." The action, which served as an indictment of the Mexican government's lack of attention to

10. In 1968, Oscar Bony of Argentina put a worker family on a podium in a gallery and paid them double their regular wages for posing as works of art. The Nordic duo Elmgreen and Dragset contracted two unemployed house painters in Leipzig to execute an extended version of their performance *12 Hours of White Paint*, renamed *Between Other Events*." (As the house painters painted the gallery walls for a total of seven weeks, this performance slowly unfolded as a commentary on the depressed labor conditions in eastern Germany.)

indigenous communities, pointed out the severe neglect many still face in the way of education. According to a recent estimate, over 20 million Mexicans are illiterate or cannot speak Spanish, the official language of the Mexican republic. The piece provoked many through Sierra's supposed exploitation of elderly women, a fact that still manages to elicit overly sentimental reactions from many of his critics.

While it is important to note that most of the artists in *Made in Mexico* represent a generation that is aware of and informed by one another's practice, this is only a sample of those who have worked or are currently working in Mexico or on Mexican themes. Earlier exhibitions have examined international artists whose work made a significant impact in Mexico in the twentieth century. Art historian Jay Oles has done extensive research into the early muralism projects of Philip Guston, Ruben Kadish, and Isamu Noguchi. José Clemente Orozco heavily influenced Jackson Pollock's work, while the American photographer Helen Levitt, who lived in Mexico City in 1941, produced a remarkable pictorial essay that illustrated the city's rapid urbanization and tremendous social and economic change at that time. Within the last twenty years, artists such as José Bedia and Jimmie Durham have spent substantial time in Mexico, where they focused on indigenous communities. The rituals and symbolism of Seri, Yaqui, Huichol, and other indigenous communities along with Afro-Cuban belief systems have influenced Bedia, who left Cuba for Mexico in 1990. In Guadalajara there is now a burgeoning young artist scene, while in Baja California there are several generations of artists who are making a significant impact within contemporary art.[11]

Given the number of international artists who have passed through Mexico over the last century and who have contributed to its aesthetics and culture directly or indirectly, it is clear that external forces have always informed regionality and difference, cultural politics, and utopian aspirations. Paradoxically, as we begin to reassess generally accepted terms such as globalism, it is also clear that this must be done in relation to more specific national formations of political and social organization. Nevertheless, as many critics agree, it is no longer viable to study literature and culture as delimited in some way by national histories and spaces given the changes brought about in national economics, politics and culture.[12] Carl Good writes of the "effort to treat 'Mexico' as an open sign of something that owes its effect to its possibility of evoking itself from outside its own borders. Such a possibility — that "Mexico" speaks outside of itself – has many consequences for critics of Mexican history and art."[13] These consequences also have definite significance for art in general. To pose the question "What makes art Mexican?" at precisely the moment when geopolitical economics and mass communications dominate the social and cultural sphere is to engage in a critical inquiry into how nationalist agendas and generalizations about culture intersect. While there may not be a clear-cut answer to that question, *Made in Mexico* instead attempts to pose the question from as many creative, ethnic, and sociopolitical perspectives as possible. GV

11. The Museum of Contemporary Art, San Diego, is organizing an exhibition for 2005 that will survey the art scene in Tijuana, Baja California.

12. Good and Waldron, eds., The Effects of the Nation, p. 2.

13. Ibid.

Made in Mexico
The Artists

Selected Solo Exhibitions
1999
Recent Models and Freaks, Jack Tilton Gallery, New York, New York

1997
Paseos del eter..., OMR Gallery, Mexico City, Mexico

1994
Wart Mart: Sculptures and Installation by Eduardo Abaroa, Corpus Collosum, Guadalajara, Mexico

Selected Group Exhibitions
2002
Sunday Afternoon, 303 Gallery, New York, New York

2000
Pleasure Treasure, Harriet and Charles Luckman Fine Arts Gallery, California State University, Los Angeles

1996
En transito: senales presentes, Fundación Banco Patricios, Buenos Aires, Argentina

Selected Bibliography
Carmen Lira Saade, "Ruben Ortiz y Eduardo Abaroa colaboran en Calimcho Style," *La Jornada*, May 6, 2002.

Christopher Knight, "inSite, Outta Sight," *Los Angeles Times*, October 4, 1997.

Yishai Jusidman, "Eduardo Abaroa, Arena Mexico," *Artforum*, June 1995.

Eduardo Abaroa
Born in Mexico City, 1968. Lives and works in Mexico City.

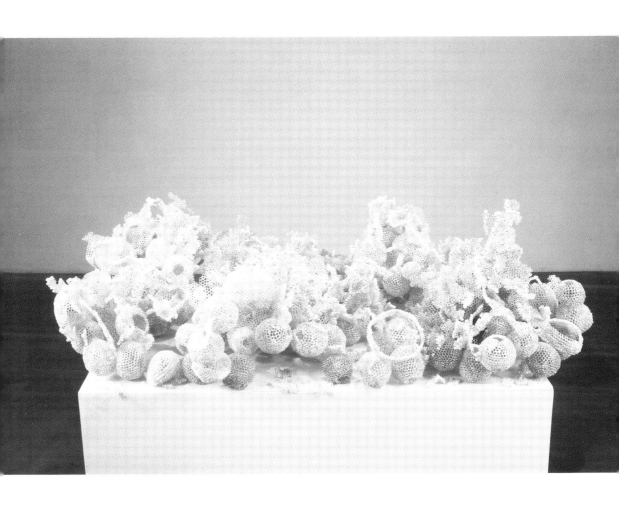

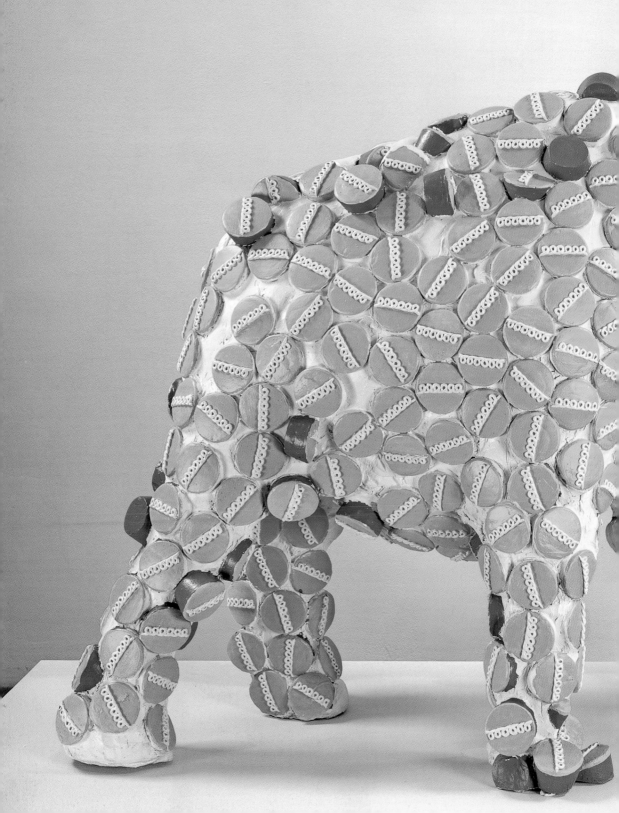

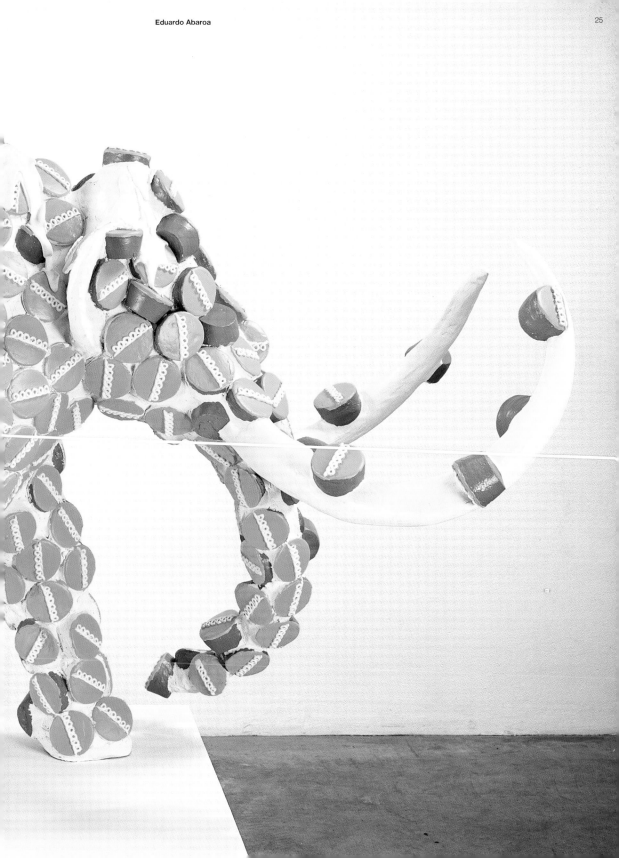

Selected Solo Exhibitions
2003
Francis Alÿs. El profeta y la mosca. Obra pictórica 1992–2003. Museo Nacional Centro de Arte Reina Sofía, Madrid, Spain

2002
Projects 76: Francis Alÿs: Modern Procession, Museum of Modern Art, New York, New York

2001
1-866-FREE-MATRIX, Wadsworth Atheneum Museum of Art, Hartford, Connecticut

Selected Group Exhibitions
2002
Structures of Difference, Wadsworth Atheneum Museum of Art, Hartford, Connecticut

2001
Painting at the Edge of the World, Walker Art Center, Minneapolis, Minnesota

1999
Reality and Desire, Fundación Joan Miró, Barcelona, Spain

Selected Bibliography
Catherine Lampert, *Francis Alÿs: The Prophet and the Fly*. Madrid: Turner, 2003.

Anne Wehr, *Francis Alÿs: The Modern Procession*. New York: Public Art Fund, 2003.

Michael Darling, "Francis Alÿs and the Return to Normality," *Frieze*, March-April 1997.

Francis Alÿs
Born in Antwerp, Belgium, 1959. Lives and works in Mexico City.

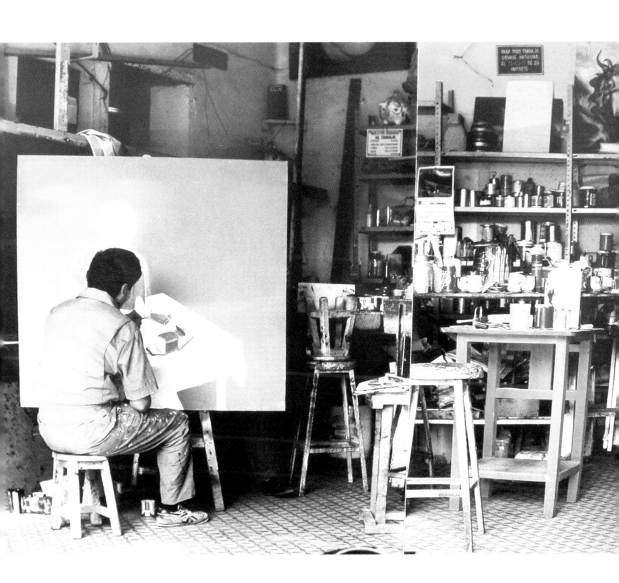

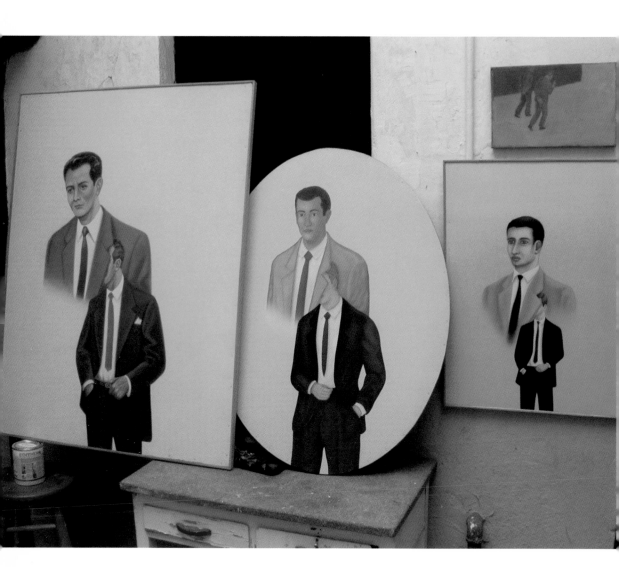

Selected Solo Exhibitions
2003
Mi vida es otra/My Life is Yet Something Else, Iturralde
Gallery, Los Angeles, California

2001
Panoramica, Espacio 3, Mexico City, Mexico

1998
Diferencias reunidas, Palacio de Bellas Artes, Mexico
City, Mexico

Selected Group Exhibitions
2002
*Axis Mexico: Common Objects and Cosmopolitan
Actions*, San Diego Museum of Art, San Diego,
California

2001
Gather and Tell, Mexican Cultural Institute, New York,
New York

1998
Imaginaires mexicaines, Musée de la Civilisation de
Québec, Quebec, Canada

Selected Bibliography
Holly Myers, "A charming fascination," *Los Angeles
Times*, Calendar, April 25, 2003.

Priya Bhatnagar, "Focus Mexico: Contemporary
Mexican Art Today," *Flash Art*, July/September 2002.

Christopher Knight, "The Border Realigned," *Los
Angeles Times*, Calendar, September 20, 2002.

Claudia Fernández
Born in Mexico City, 1965. Lives and works in Mexico City.

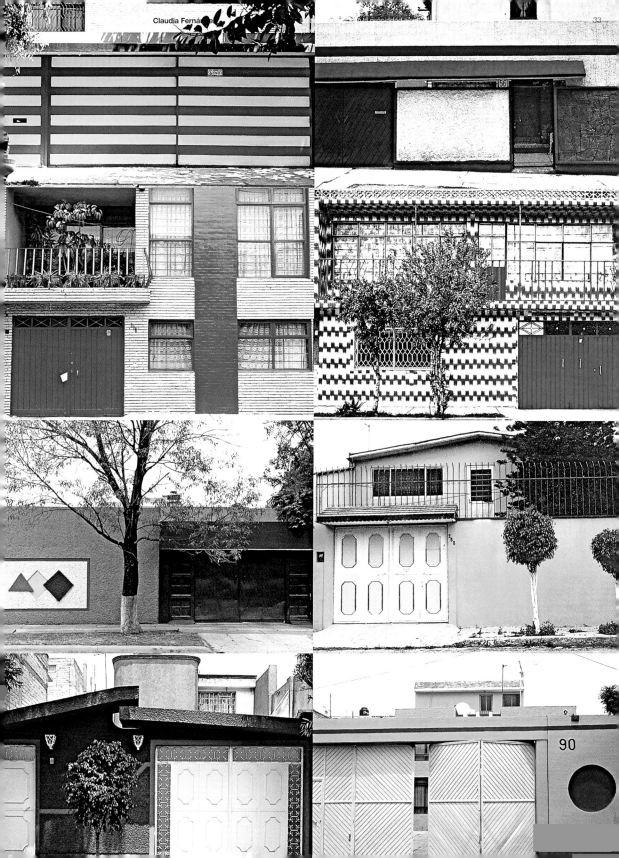

Claudia Fernán...

La belleza oculta en la propiedad ajena
(The Hidden Beauty in Someone Else's Property), 2000

Claudia Fernández

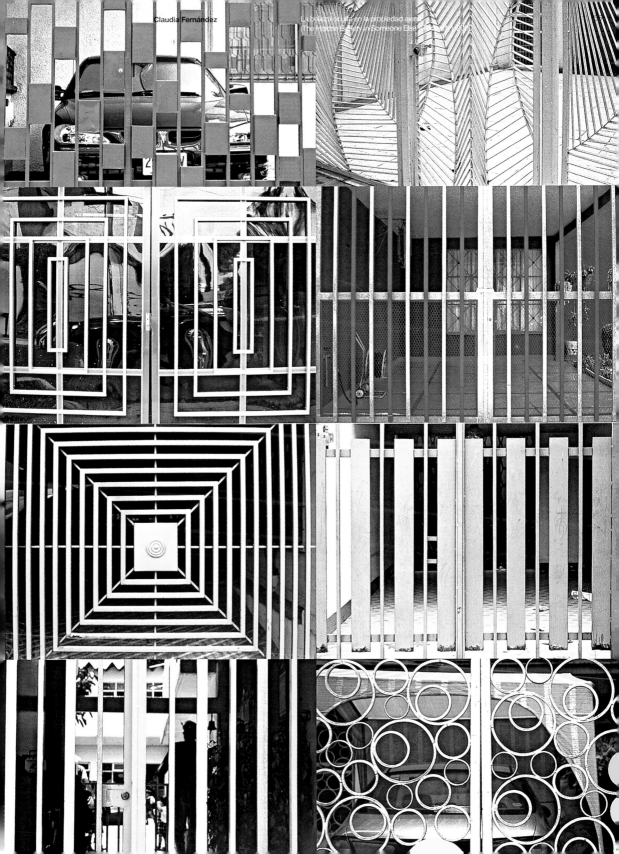

Claudia Fernández

La belleza oculta en la propiedad ajena
(The Hidden Beauty in Someone Else's...)

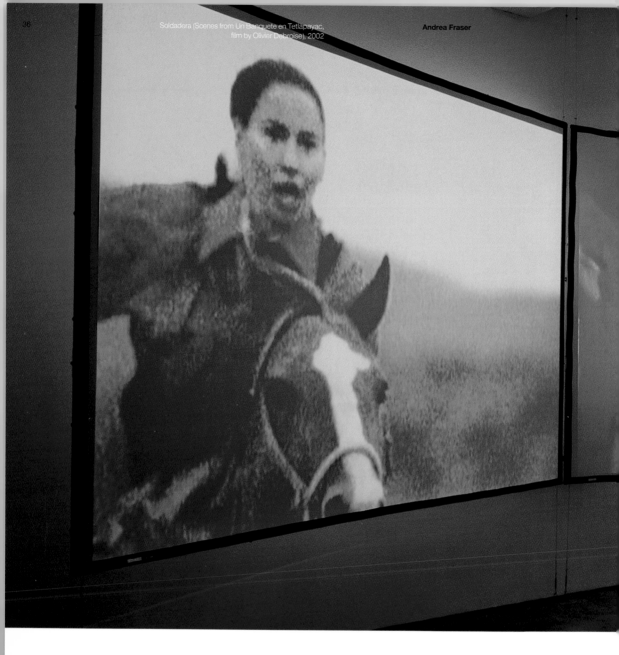

Soldadera (Scenes from Un Banquete en Tetlapayac, film by Olivier Debroise), 2002

Andrea Fraser

Selected Solo Exhibitions
2003
Works: 1984 to 2003, Kunstverein Hamburg, Germany

2002
Exhibition, The Belkin Art Gallery, University of British Columbia, Vancouver

1998
1998 Reporting from São Paulo, I'm from the United States, for *Roteiros. Roteiros. Roteiros. Roteiros. Roteiros. Roteiros. Roteiros*, 24th Bienal de São Paulo, Brazil

Selected Group Exhibitions
2003
Image Stream, Wexner Center for the Arts, Ohio State University, Columbus, Ohio

2001
SIGHT/SITE: Objects Subject to Change, Institute of Contemporary Art, Philadelphia, Pennsylvania

1999
Museum as Muse, Museum of Modern Art, New York, New York

Selected Bibliography
Andrea Fraser, "Performance Anxiety," *Artforum*, February 2003.

Kynaston McShine (ed.), *Museum as Muse: Artists Reflect*. New York: Museum of Modern Art, 1999.

Jorge Ribalta, *Andrea Fraser: Conversaciones sobre financiación pública y arte contemporáneo*. Salamanca: Universidad de Salamanca, 1998.

Andrea Fraser
Born in Billings, Montana, 1965. Lives and works in New York City.

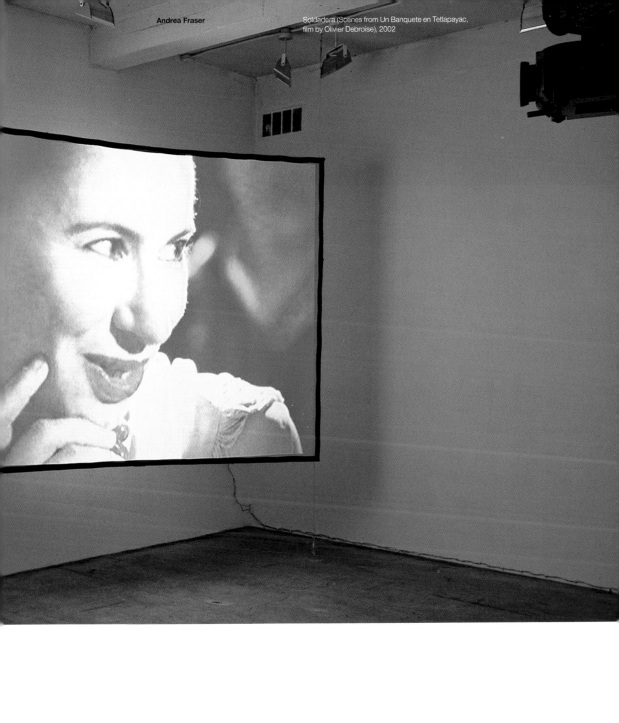

Andrea Fraser

Soldadera (Scenes from Un Banquete en Tetlapayac,
film by Olivier Debroise), 2002

Selected Solo Exhibitions
2003
Museo Carrillo Gil, Mexico City, Mexico

2002
Finesilver Gallery, San Antonio, Texas

2001
Desire, OMR Gallery, Mexico City, Mexico

Selected Group Exhibitions
2003
Mexico, identidad y ruptura, Fundación Telefónica, Madrid, Spain

2001
Do It, Museo Carrillo Gil, Mexico City, Mexico

1999
Yo y mi circunstancia, Museé des Beaux Arts de Montréal, Montreal, Canada

Selected Bibliography
Robert L. Pincus, "Reverberations and Echoes: Glassford's works for the wall are of a different stripe," *San Diego Union-Tribune*, April 18, 2002.

Francisco Rivero Lake, "Thomas Glassford, Galería OMR," *Art Nexus*, January-March, 2002.

Kurt Hollander, "Crossover Dreams," *Art in America*, May 1998.

Thomas Glassford
Born in Laredo, Texas, 1963. Lives and works in Mexico City.

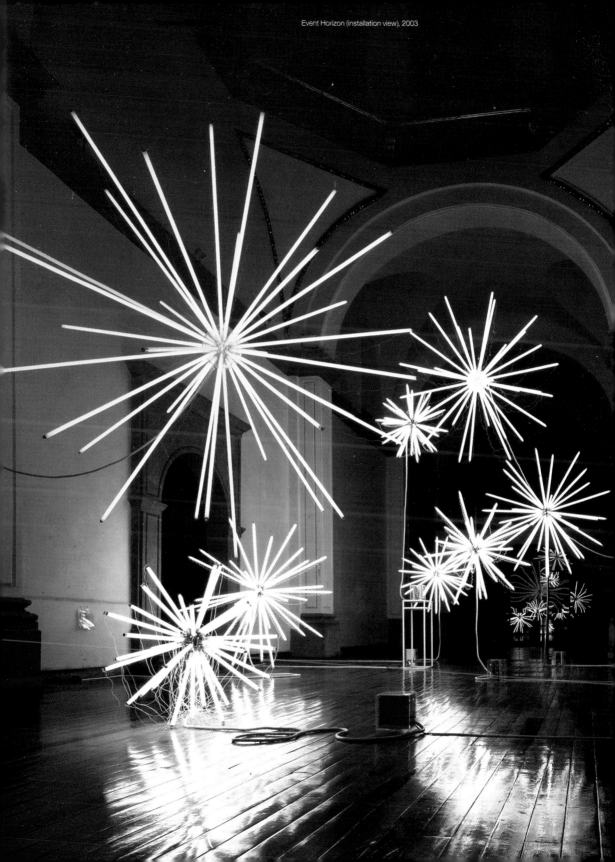

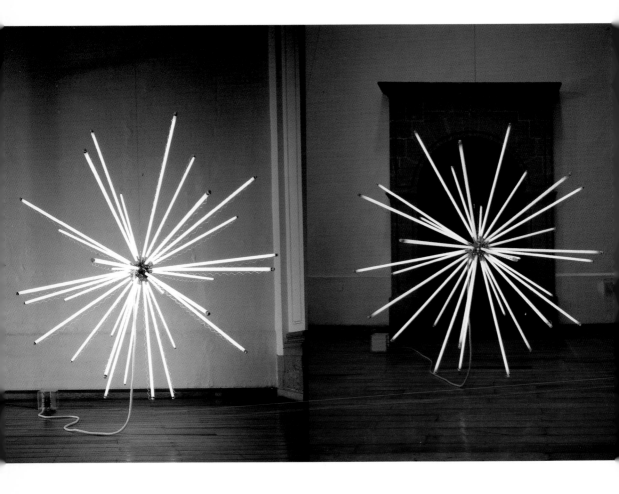

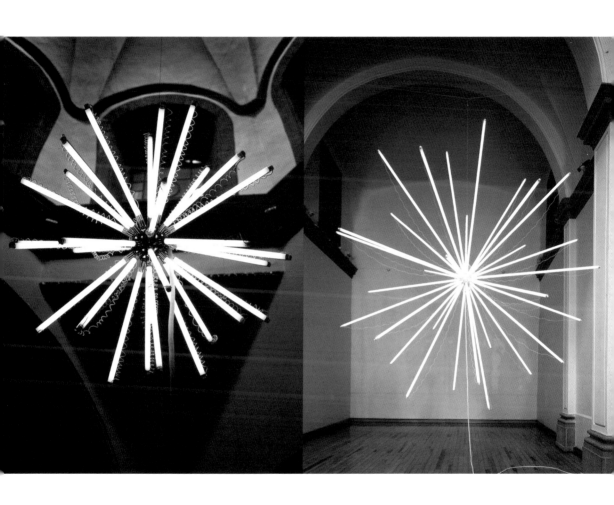

Selected Solo Exhibitions
Selected Solo Exhibitions
2003
Ihr Reiseplan - your travelling map, Kunstverein München, Munich, Germany

1999
Interface Rue du Chevaleret, [batofar], Paris, France

1997
READY MIX - Erik Göngrich - ON SITE, daily from 14 p.m., Pavilion of the Volksbühne at the Rosa-Luxemburg-Platz, Berlin, Germany

Selected Group Exhibitions
2001
becoming a place, proje 4L, Museum of Contemporary Art, Istanbul, Turkey

1999
City Editings, Fundación Proa, Buenos Aires, Argentina

1998
What's really necessary to add to reality?, plattform, Berlin Biennale, Germany

Selected Bibliography
Erik Göngrich, *picnic city**, Published by the artist, Museum of Contemporary Art, Istanbul, 2001.

Erik Göngrich, *Sitting abroad*, Mexico City, Bogotá, Buenos Aires, Published by the artist, 2000

Erik Göngrich, *Interface Rue du Chevaleret*, [batofar], Paris, Published by the artist, 1999

Erik Göngrich

Born in Kirchheimbolanden, Germany, 1966. Lives and works in Berlin, Germany.

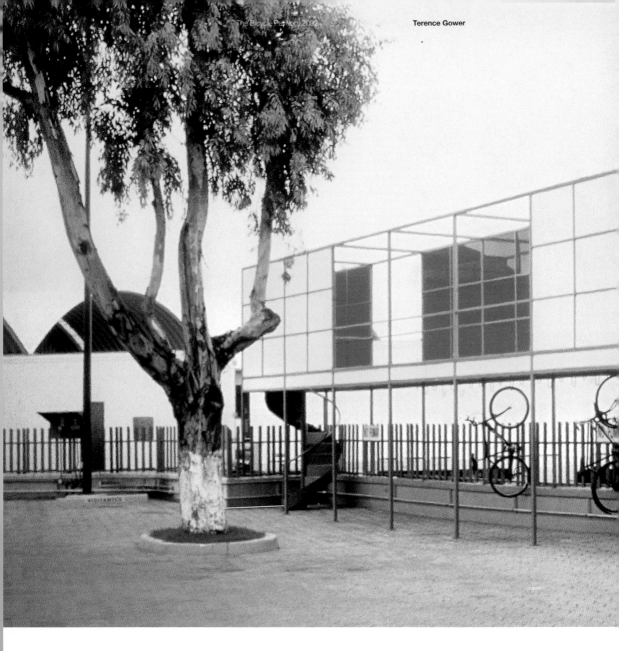

Selected Solo Exhibitions
2002
Exhibición, Galeria HR, Mexico City, Mexico

1998
Mal de archive, Art Deposit, Mexico City, Mexico

1997
Display Library, Poliester, Mexico City, Mexico

Selected Group Exhibitions
2004
Plane and Elevation, Art in General, New York, New York

2003
Stretch, The Power Plant, Toronto, Canada

2001
La estrategía, Sala de arte público Siqueiros, Mexico City, Mexico

Selected Bibliography
Alberto López Cuenca, "Thisplay," *Lapiz*, Madrid, January 2003.

Laura Santini, "Terence Gower: un canadese a Bogliasco," *mentelocale.it*, Genoa, Italy, December 2001.

Ernesto Sosa, "Promo," *Art Nexus* 37, Columbia, August-October 2000.

Terence Gower
Born in Canada. Lives and works in New York and Mexico City.

Sombrero, 2002

Terence Gower

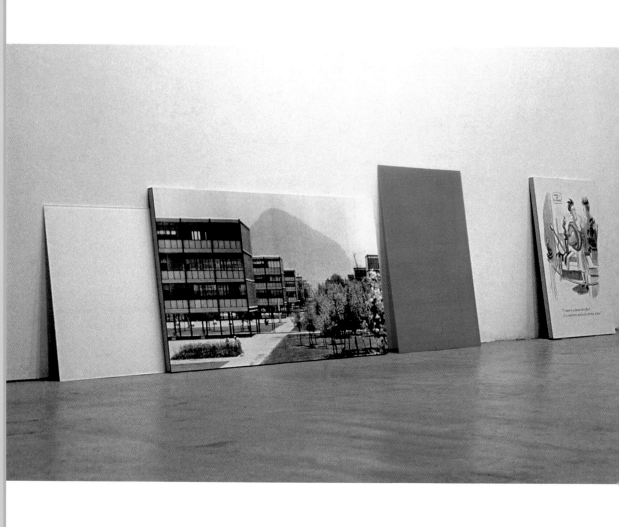

Selected Exhibitions
2001
Museum of Modern Art, New York, New York

1999
Serpentine Gallery, London, England

1998
Kunsthalle, Düsseldorf, Germany

Selected Group Exhibitions
2000
Sydney Biennial, Sydney, Australia

1999
Great Illusions—Demand, Gursky, Ruscha, Museum of
Contemporary Art, Miami, Florida

1997
Young German Artists 2, Saatchi Gallery,
London, England

Selected Bibliography
Andreas Gursky, essays by Peter Galassi and Glenn
Lowry. New York: Museum of Modern Art, 2002.

*Andreas Gursky: Photographs from 1984 to the
Present,* essays by Marie Luise Syring, Lynne Cooke,
and Rupert Pfab. Düsseldorf: Te Neues Publishing
Company, 2001.

Great Illusions: Demand, Gursky, Ruscha, essays
by Dietrich Diederichsen, Stefan Gronert, and Ralph
Rugoff. Miami: Museum of Contemporary Art, 1999.

Andreas Gursky
Born in Leipzig, Germany, 1955. Lives and works in Düsseldorf, Germany.

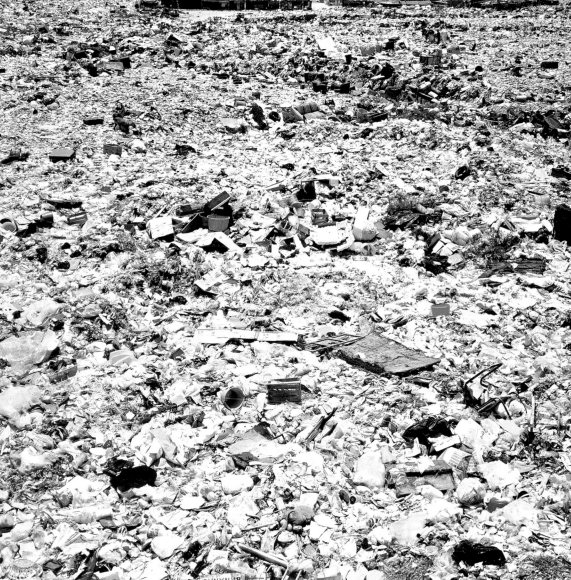

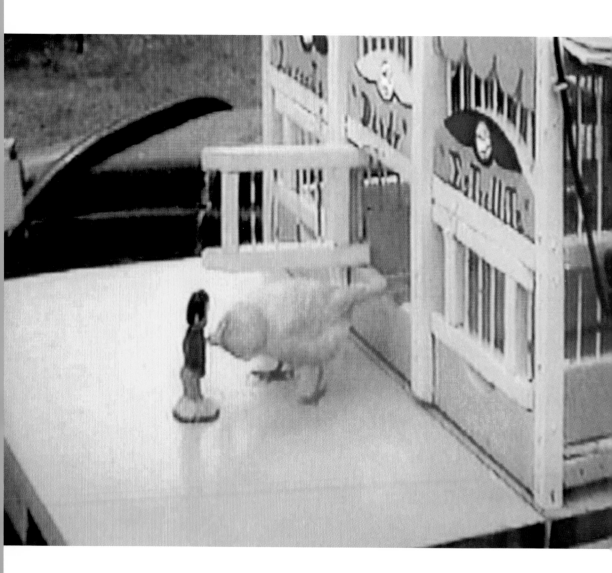

Selected Solo Exhibitions
2002
Mona Hatoum, Laboratorio Arte Alameda, Mexico
City, Mexico

2001
Mona Hatoum: Domestic Disturbance, MASS MoCA,
North Adams, Massachusetts

2000
Mona Hatoum, The Entire World as a Foreign Land,
Tate Britain, London

Selected Group Exhibitions
2002
Imagine, You Are Standing Here in Front of Me,
Museum Boijmans Van Beuningen, Rotterdam, The
Netherlands

2000
Making Choices: Seeing Double, Museum of Modern
Art, New York, New York

1997
*Sensation: Young British Artists from the Saatchi
Collection*, Royal Academy of Arts, London;
Hamburger Bahnhof, Berlin; Brooklyn Museum of Art,
New York

Selected Bibliography
Mona Hatoum, essays by Francisco Reyes Palma and
Maria Inés Garcia Canal. Mexico City: Laboratorio Arte
Alameda, 2002.

Mona Hatoum: Domestic Disturbances, interviews
with Janine Antoni and Jo Glencross, essays by
Louis Grachos, Laura Steward Heon, and Joseph C.
Thompson. North Adams: MASS MoCA; Santa Fe:
SITE Santa Fe, 2001.

Mona Hatoum: The Entire World as a Foreign Land,
essays by Edward W. Said and Sheena Wagstaff,
London: Tate Gallery Publishing LTD, 2000.

Mona Hatoum
Born in Beirut, Lebanon, 1952. Lives and works in London, England.

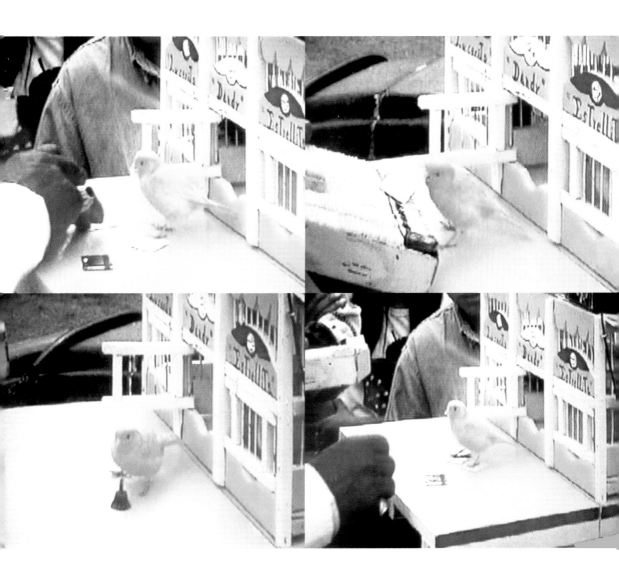

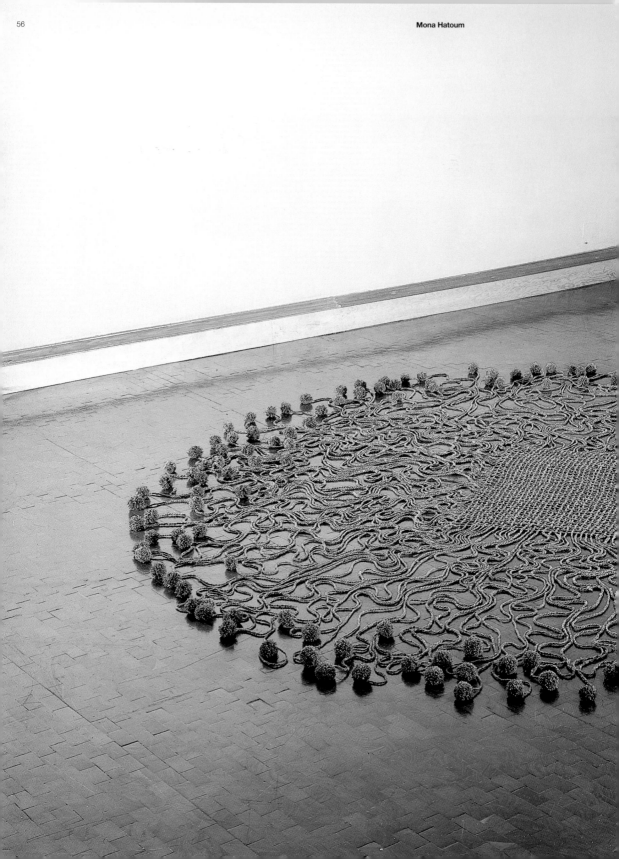

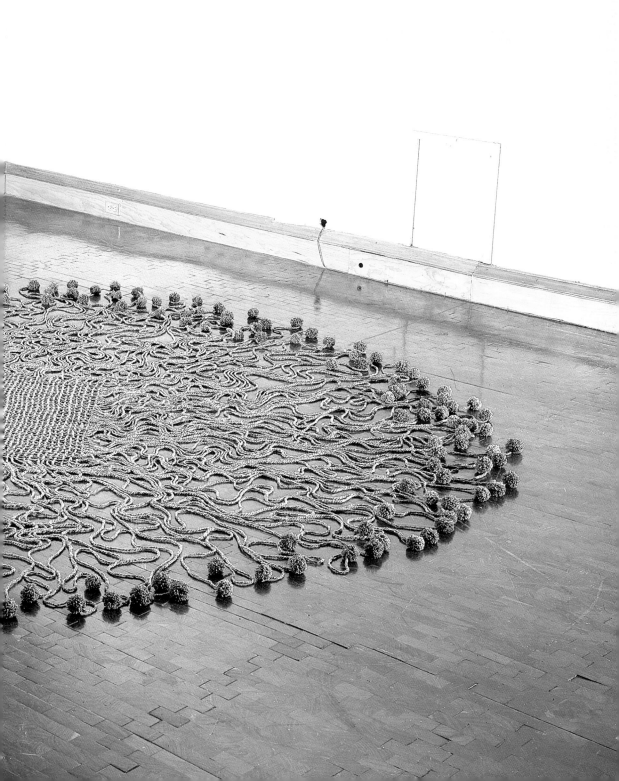

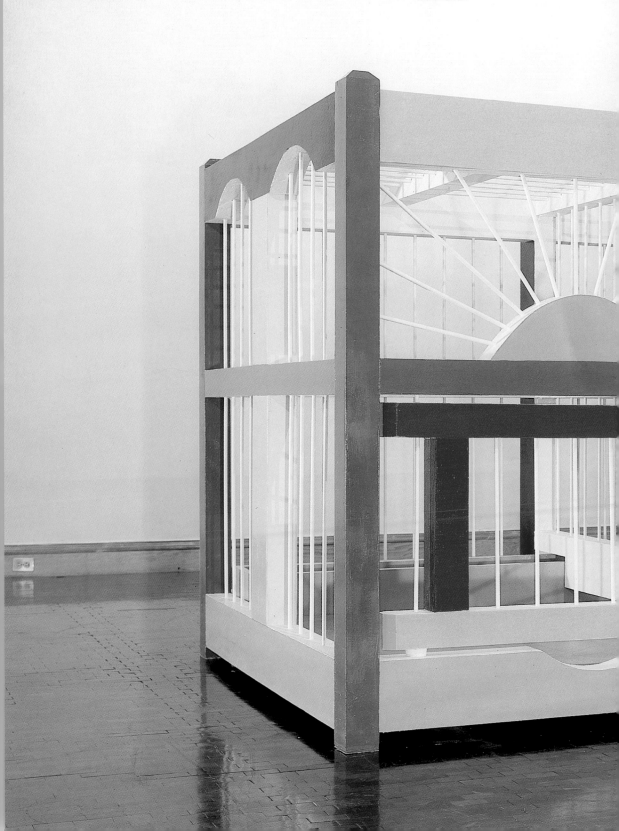

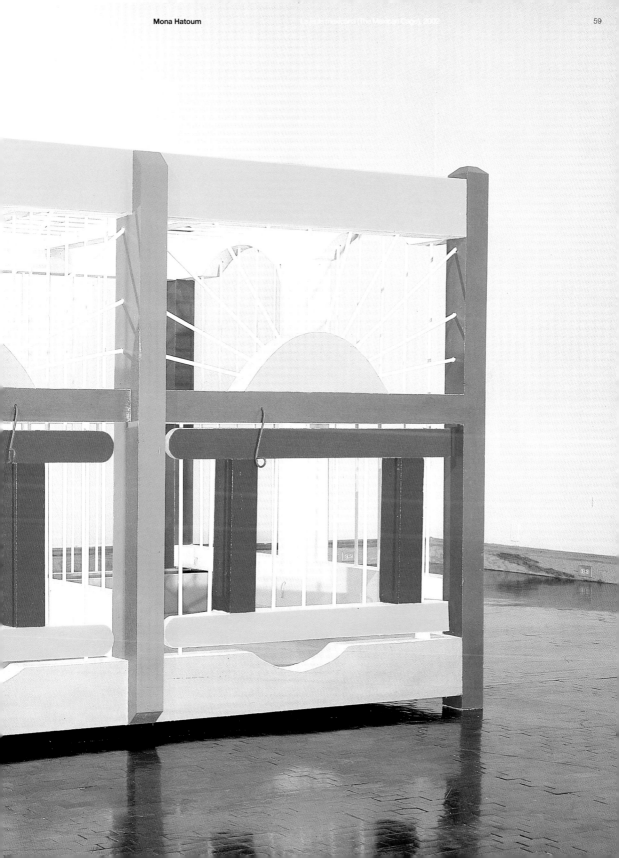

Selected Solo Exhibitions
2004
Fogg Art Museum, Cambridge, Massachusetts

2001
Museum of Contemporary Art, Chicago, Illinois

2000
Kunsthalle Zürich/Kunstmuseum Wolfsburg, Germany

Selected Group Exhibitions
2002
General Thinking: Art of the 1990s, San Diego Museum of Contemporary Art, San Diego, California

2001
From Jasper Johns to Jeff Koons: Four Decades of Art from the Broad Collection, Los Angeles County Museum of Art, Los Angeles, California

1998
Scratches on the Surface of Things, Museum Boijmans Van Beuningen, Rotterdam, The Netherlands

Selected Bibliography
Sharon Lockhart, essays by Sharon Lockhart, Dominic Molon, and Norman Bryson. Chicago: Museum of Contemporary Art, 2001.

Sharon Lockhart: Teatro Amazonas, essays by Timothy Martin, and Karel Schampers. Rotterdam: NAi Publishers, 2000.

John Alan Farmer, "Sharon Lockhart: Interview Locations/Family Photographs," *Art Journal*, Spring 2000.

Sharon Lockhart
Born in Norwood, Massachusetts, 1964. Lives and works in Los Angeles, California.

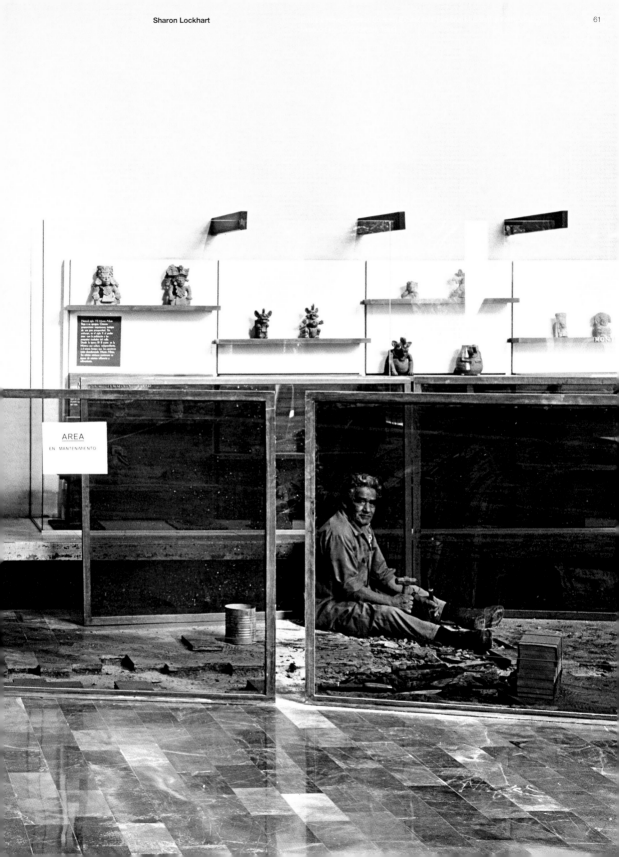

Enrique Nava Enedina: Oxacan Exhibit Hall, National Museum of Anthropology,
Mexico City 1999 (detail), 1999

Sharon Lockhart

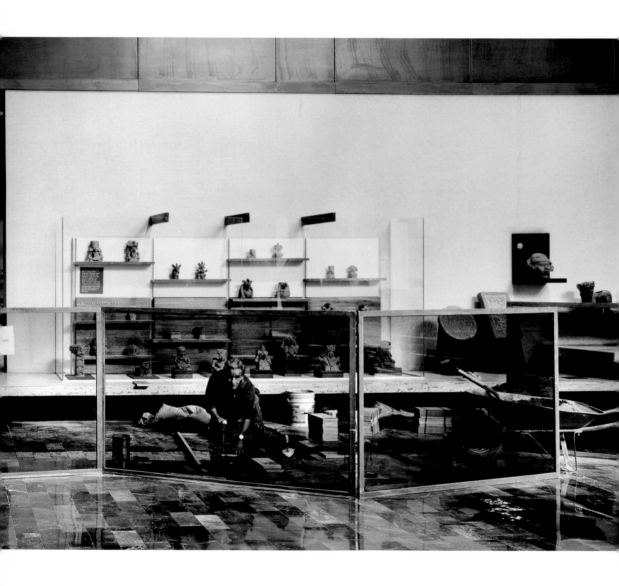

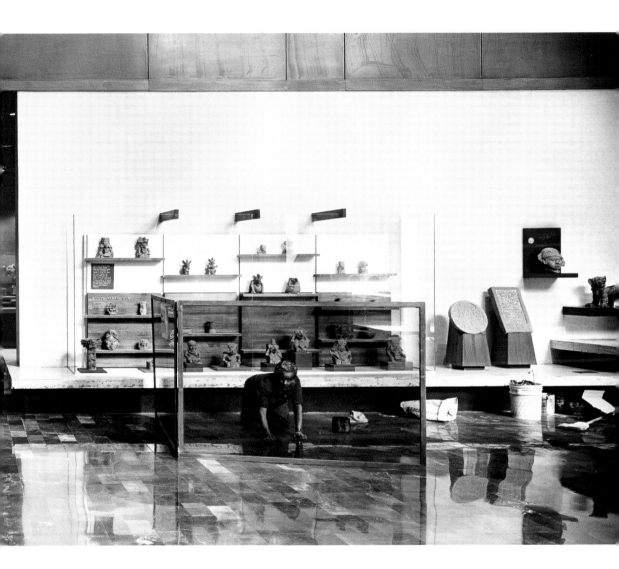

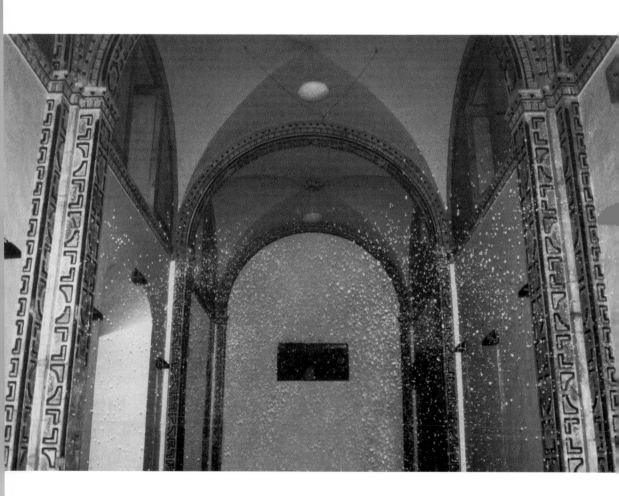

Selected Solo Exhibitions
2004
Museum für Moderne Kunst, Frankfurt/Main, Germany

2003
Das Leichentuch, Kunsthalle Wien, Vienna, Austria

2002
Fin, La Panadería, Mexico City, Mexico

Selected Group Exhibitions
2003
Beautiful banner representation/democracy/participation, I Prague Biennial, Veletržní Palác, Prague, Czech Republic

2002
Mexico: Sensitive Negotiations, The Institute of Mexico in Miami, Miami, Florida

2001
Escultura Mexicana, Museo del Palacio de Bellas Artes, Mexico City, Mexico

Selected Bibliography
Rubén Gallo, "Teresa Margolles," in *Cream 3*. London: Phaidon Press, 2003.

"Mexico City. An Exhibition about the Exchange Rate of Bodies and Values," *Art Nexus* 46, October 2002.

Klaus Biesenbach, "Hunting Men Hunting Dogs: Fear and Loathing in Mexico City," *Flash Art* 24, 2002.

Teresa Margolles
Born in Culiacán, Sinaloa, Mexico, 1963. Lives and works in Mexico City.

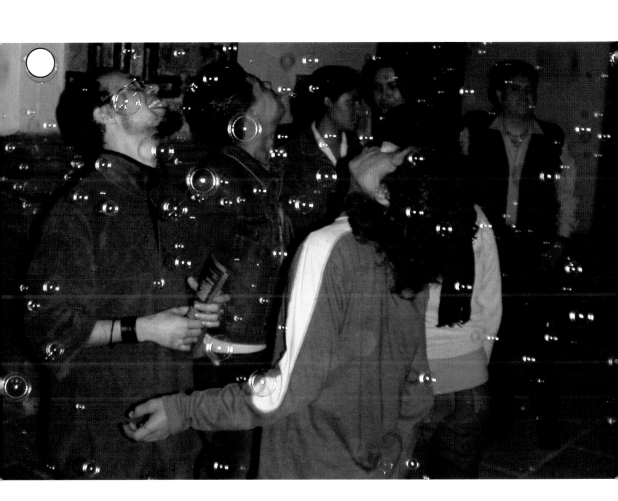

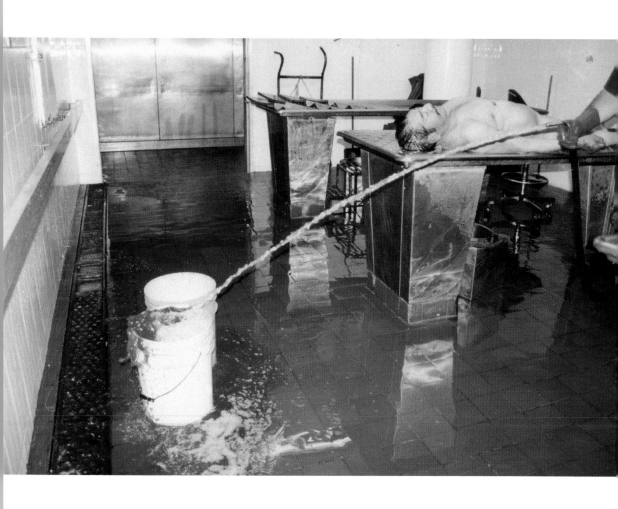

Selected Solo Exhibitions
2002
Masquerade, John Michael Kohler Arts Center,
Sheboygan, Wisconsin

Self-Portraits, Ca di Fa, Milan, Italy

2001
An Inner Dialogue with Frida Kahlo (Self-Portraits),
Luhring Augustine, New York, New York

Selected Group Exhibitions
2003
Influence, Anxiety, and Gratitude, MIT List Visual Arts
Center, Cambridge, Massachusetts

2002
*Tableaux Vivants. Living Pictures and Attitudes in
Photo-graphy, Film, and Video*, Kunsthalle Wien,
Vienna, Austria

2000
Contemporary Photography from Japan, DePont
Foundation for Contemporary Art, Tilberg, The
Netherlands

Selected Bibliography
Yasumasa Morimura: Daughter of Art History, text by
Yasumasa Morimura, New York: Aperture, 2003.

Sabine Folie and Michael Glasmeier, *Tableaux
Vivantes: Lebende und Attituden in Fotographie, Film
und Video*. Vienna: Kunsthalle Wien, 2002.

Nancy Princenthal, "Yasumasa Morimura at Luhring
Augustine," *Art in America*, December 2001.

Yasumasa Morimura
Born in Osaka, Japan, 1951. Lives and works in Osaka.

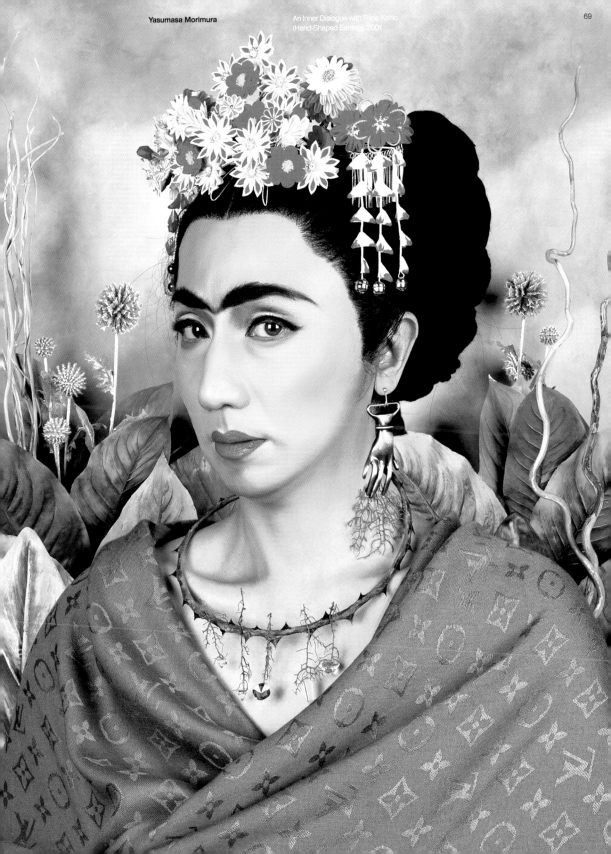

An Inner Dialogue with Frida Kahlo
(Self-Portrait with Cropped Hair 1), 2001

Yasumasa Morimura

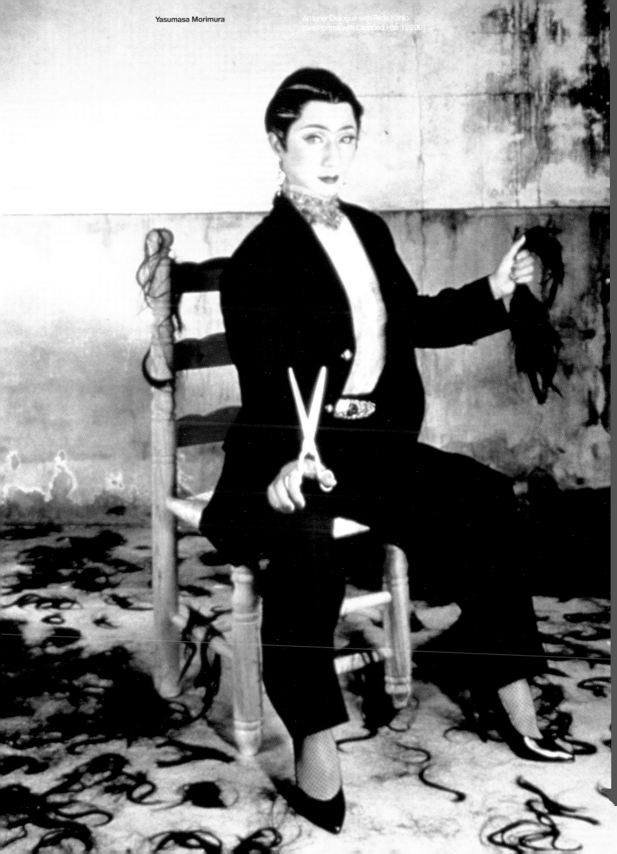

Yasumasa Morimura

An Inner Dialogue with Frida Kahlo
(Self-Portrait with Cropped Hair 1), 2001

An Inner Dialogue with Frida Kahlo
(Flower Wreath and Tears), 2001

Yasumasa Morimura

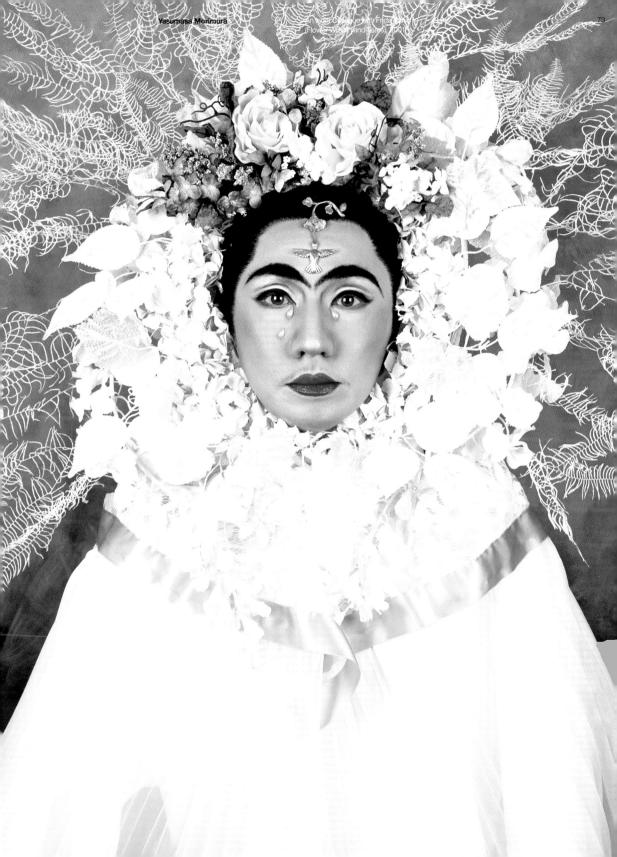

Selected Solo Exhibitions
2000
Museum of Contemporary Art, Los Angeles, California

1998
Musée Nationale d'Art Moderne de la Ville de Paris,
Paris, France

1994
Museum of Contemporary Art, Chicago, Illinios

Selected Group Exhibitions
2003
Commonwealth, Tate Modern, London, England

2002
Documenta XI, Kassel, Germany

1999
SITE Santa Fe, Santa Fe, New Mexico

Selected Bibliography
Gabriel Orozco (Clinton is Innocent), essay by
Francesco Bonami, interview by Benjamin H.D.
Buchloh. Paris: Musée Nationale d'Art Moderne de la
Ville de Paris, 1998.

Gabriel Orozco: Empty Club, essays by James
Lingwood, Jean Fisher, Mark Haworth-Booth, and Guy
Brett. London: Artangel, 1996.

Gabriel Orozco, essays by Benjamin H.D. Buchloh and
Berhard Bürgi. Zurich: Kunsthalle Zürich, Switzerland,
1996.

Gabriel Orozco
Born in Jalapa, Veracruz, Mexico, 1962. Lives and works in New York, Paris, and Mexico City.

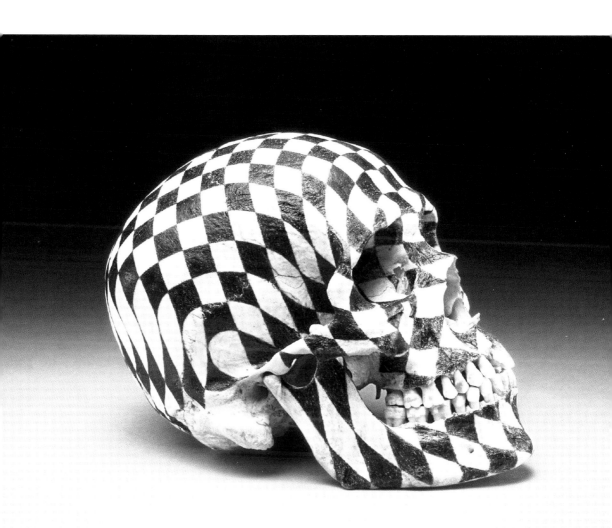

Selected Solo Exhibitions
2003
Galeria Fortes Vilaça, São Paulo, Brazil

2001
Cosmic Thing, Institute of Contemporary Art,
Philadelphia, Pennsylvania

2001
Reglas e instintos, Galería Art & Idea,
Mexico City, Mexico

Selected Group Exhibitions
2002
Biennale di Venezia, Venice, Italy

2001
Basic Instinct: Minimalism Past, Present, and Future,
Museum of Contemporary Art, Chicago, Illinois

Animations, P.S.1 Contemporary Art Center,
Long Island City, New York

Selected Bibliography
Bennett Simpson, *Damián Ortega: Cosmic Thing*,
gallery notes accompanying exhibition at Institute of
Contemporary Art, Philadelphia, September 2002.

Michael Wilson, "Damián Ortega," *Frieze*, May 2002.

Octavio Zaya, "Damián Ortega," in *Fresh Cream*.
London: Phaidon Press, 2000.

Damián Ortega
Born in Mexico City, 1967. Lives in Mexico City.

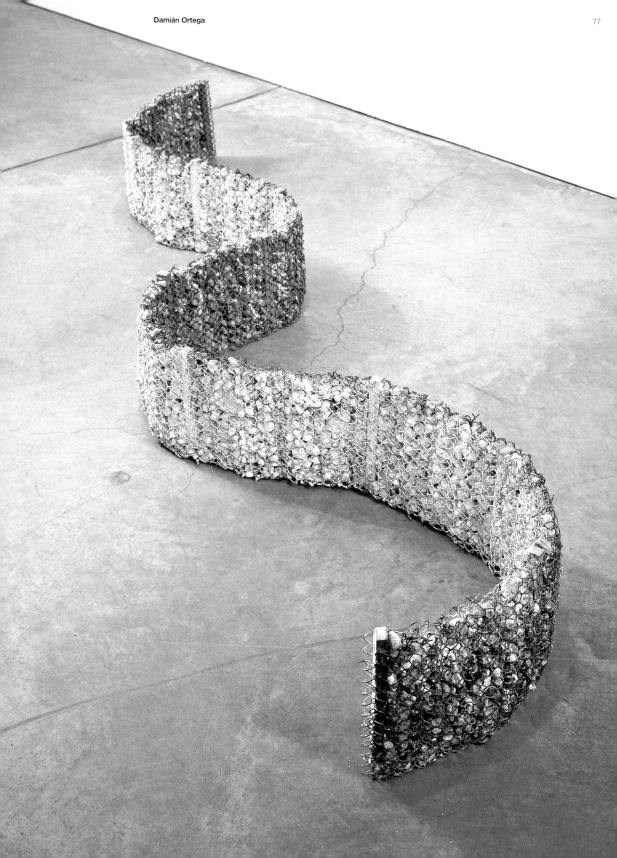

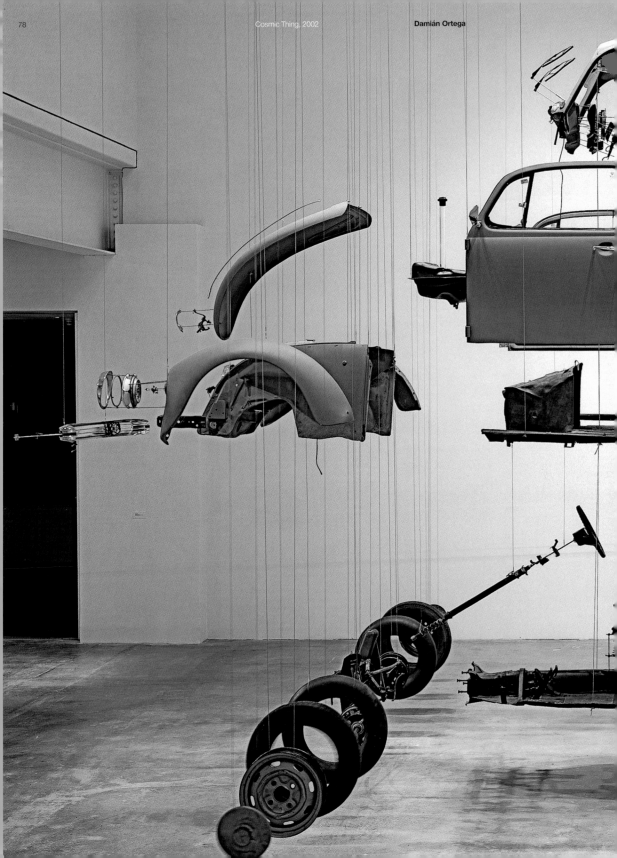

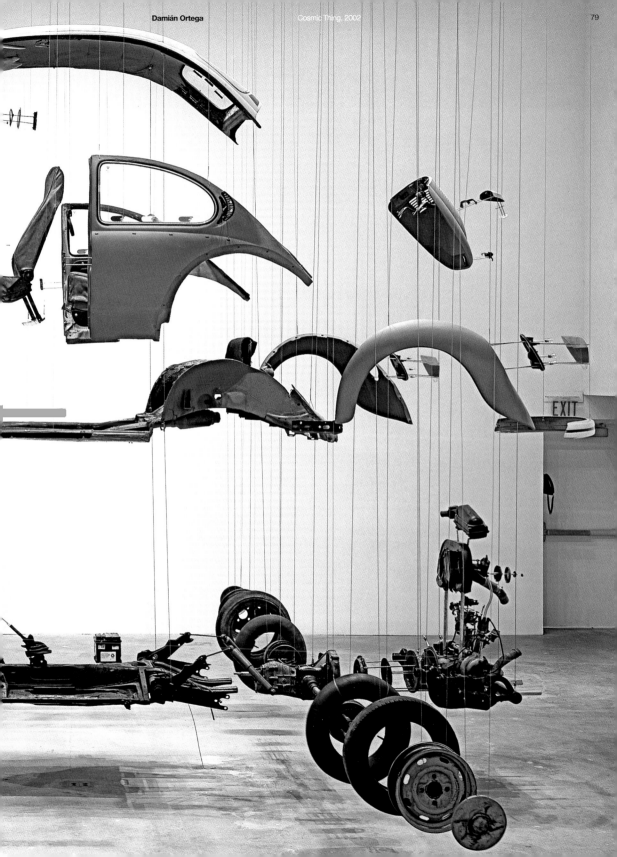

Adentro/afuera (Superficie modulada)
[Inside/Outside (Modulated Surface)], 2002

Damián Ortega

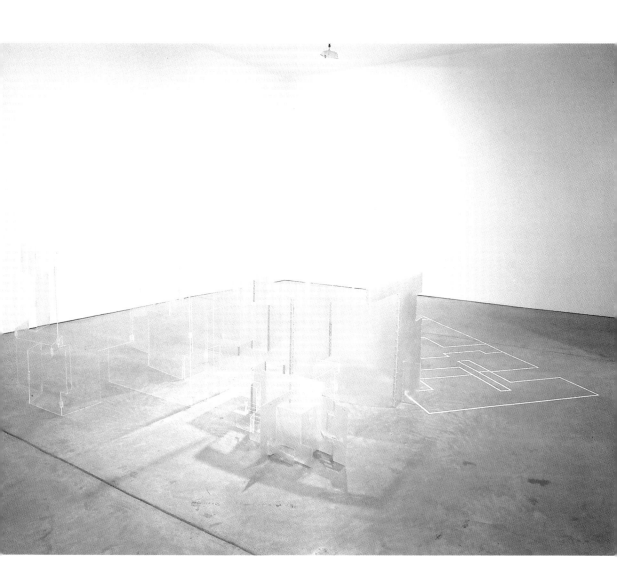

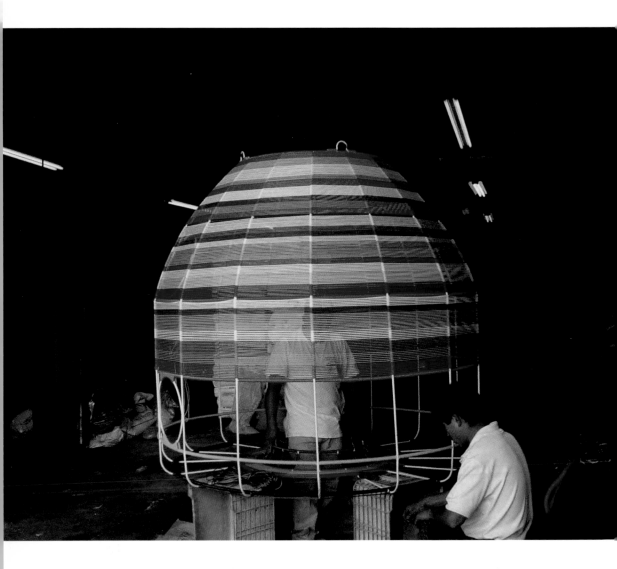

Selected Solo Exhibitions
2002
Nomenclatura arquímica, Sala de Arte Público
Siqueiros, Mexico City, Mexico

Parque Vertical, La Panadería, Mexico City, Mexico

2000
Psico-horticultura, La Torre de los Vientos, Mexico
City, Mexico

Selected Group Exhibitions
2002
20 Millions of Mexicans Can't Be Wrong, South
London Gallery, London, England

New Acquisitions, Jumex Foundation, Mexico City,
Mexico

2001
Do It, Museo de Arte Carrillo Gil, Mexico City, Mexico

Selected Bibliography
Anthony Huberman et al., *Mexico City: An Exhibition
About the Exchange Rates of Bodies and Values*. New
York: P.S.1 Contemporary Art Center, 2003.

Pedro Reyes
Born in Mexico City, 1971. Lives and works in Mexico City.

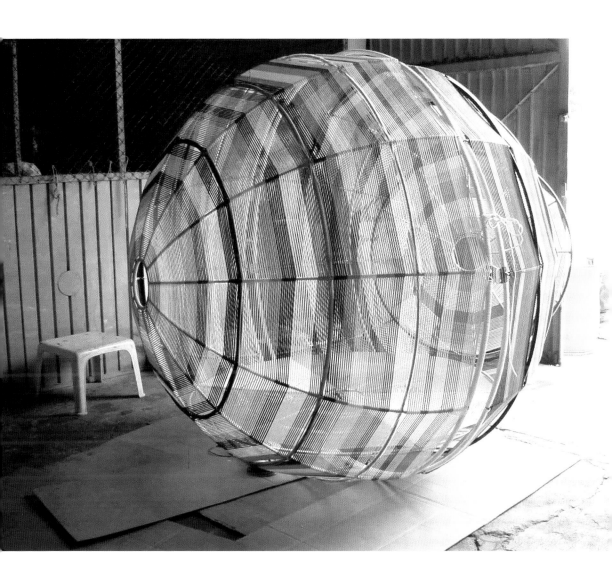

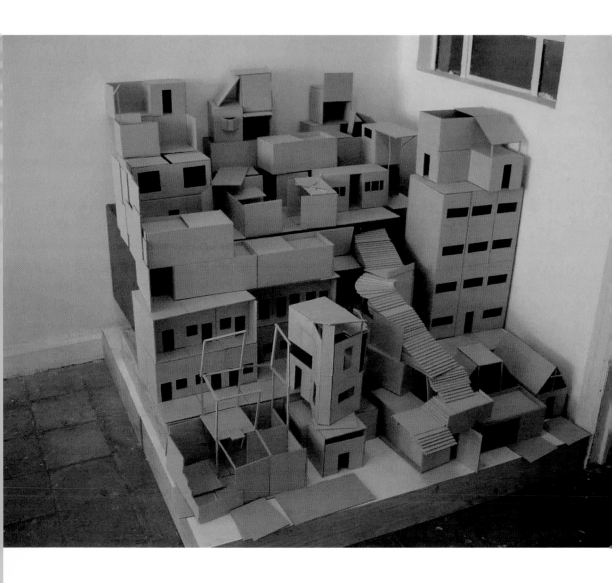

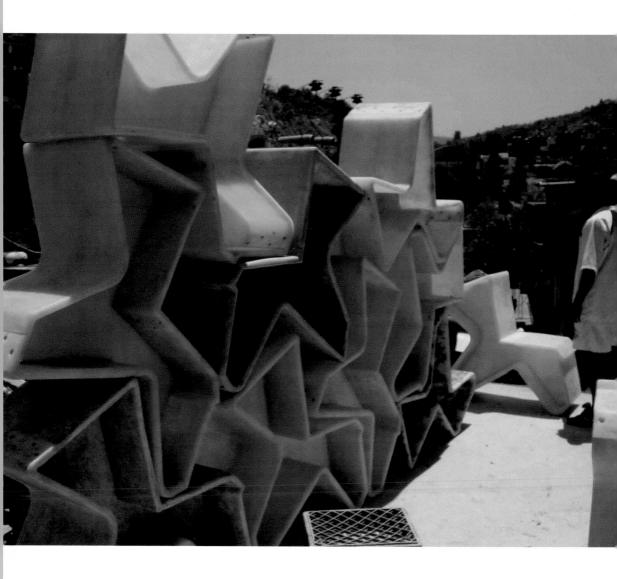

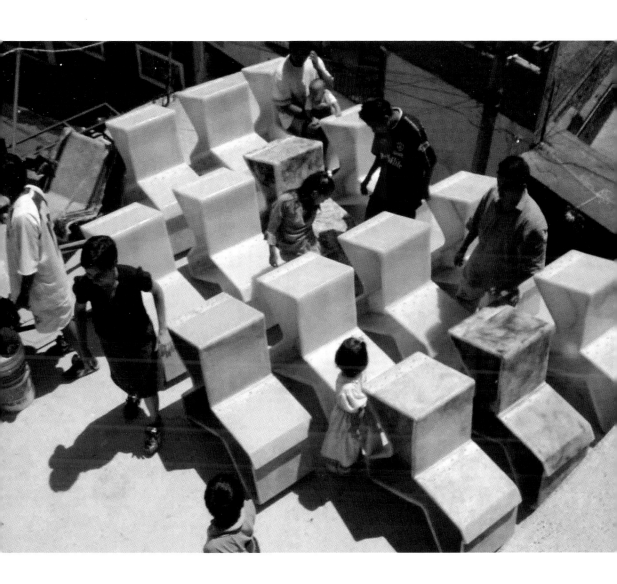

Selected Solo Exhibitions
2003
De ciudades y espacios, Galería OMR, Mexico City,
Mexico

Tipos de tiempos/especies de espacios,
Project Room, Artist Space, New York, New York

1999
Constellation + Victoria Ferox, Massimo Audiello
Fine Art, New York, New York

Selected Group Exhibitions
2003
Puddle-Wonderful, Artemis-Greenberg Van Doren,
New York, New York

2001
Tendencias/VI Salón de Arte BBVA-Bancomer,
Museo de Arte Moderno, Mexico City, Mexico

1999
*Looking at the 90's: Four Views of Current Mexican
Photography*, Queens Museum of Art, New York

Selected Bibliography
Yanin Guisande Dorado, *Aparente mente sublime*.
Mexico City: Fundación Cultural Bancomer, 2003.

Antimio Cruz, "Recrean el espacio de urbes sin
normas . . . ," *Reforma*, February 3, 2003.

David Ebony, "Mexico City on the Move,"
Art in America, December 2001.

Sebastián Romo
Born in Mexico City, 1972. Lives and works in Mexico City.

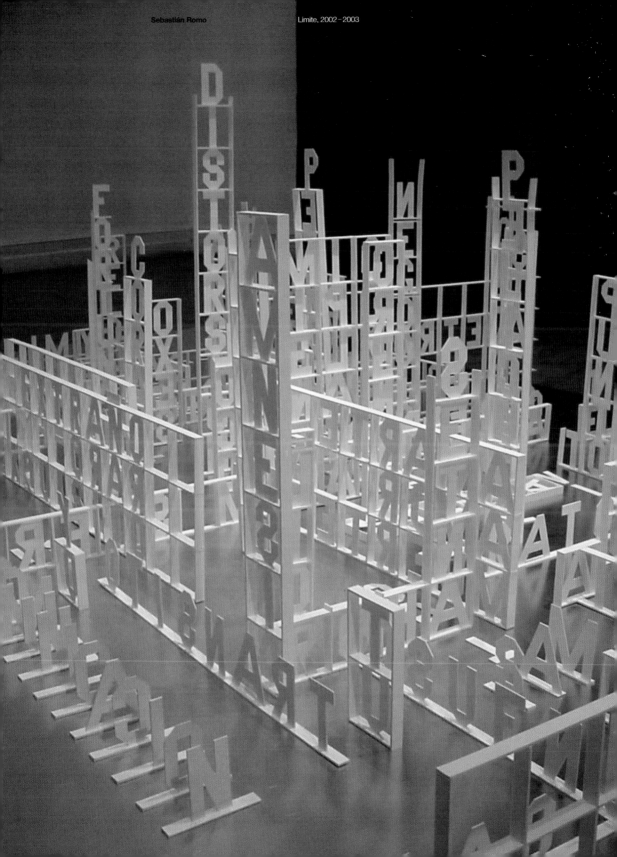

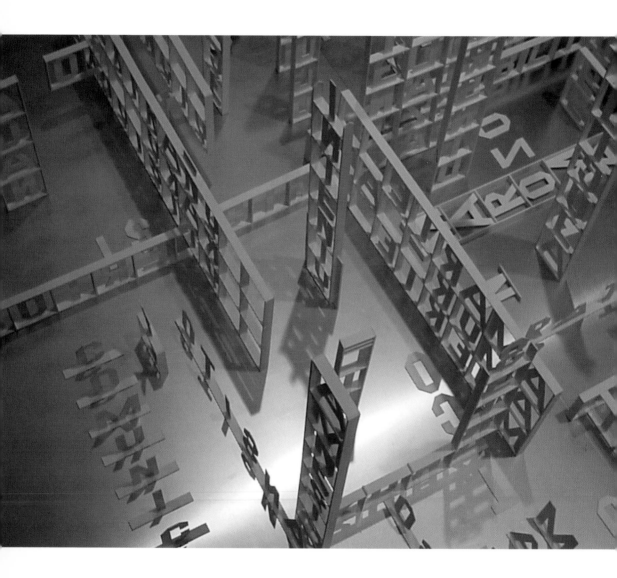

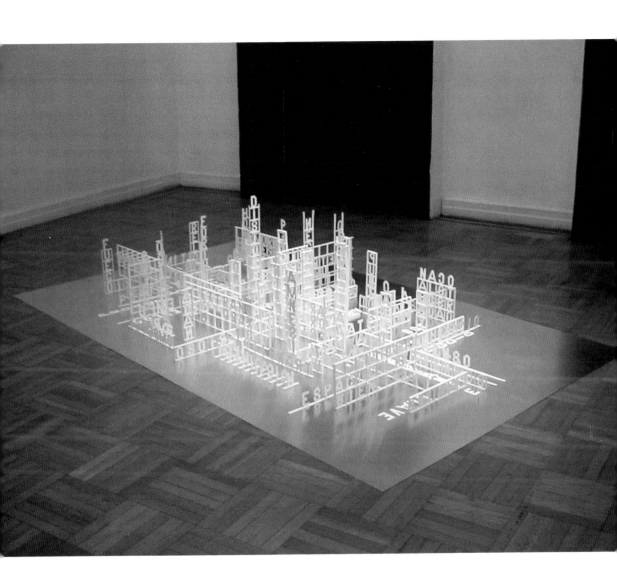

Selected Solo Exhibitions
2002
Greene Naftali, New York, New York

2001
Alberto Peola, Turin, Italy

Kevin Bruk, Miami, Florida

Selected Group Exhibitions
2002
Mexico City: An Exhibition About the Exchange Rates of Bodies and Value, P.S.1 Contemporary Art Center, New York, New York

Axis Mexico, Museum of Art, San Diego, California

2000
Policies of Difference, Pinacoteca do Estrado, São Paulo/Museum de Bellas Artes, Buenos Aires/ Museo de Arte Moderno, Mexico City

Selected Bibliography
Anthony Huberman et al., *Mexico City: An Exhibition About the Exchange Rates of Bodies and Values*. New York: P.S.1 Contemporary Art Center, 2003.

Daniela Rossell, Daniela Rossell: *Ricas y famosas*. London: Turner, 2002.

Charles Dee Mitchell, "Daniela Rossell at Greene Naftali," *Art in America*, July 2000.

Daniela Rossell
Born in Mexico City, 1973. Lives and works in Mexico City.

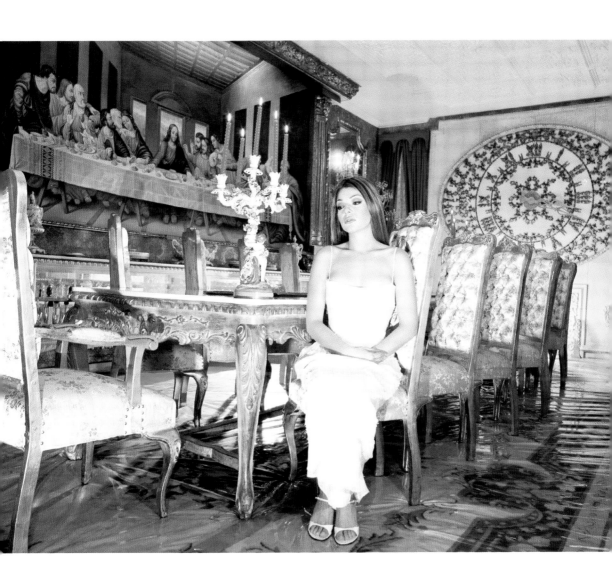

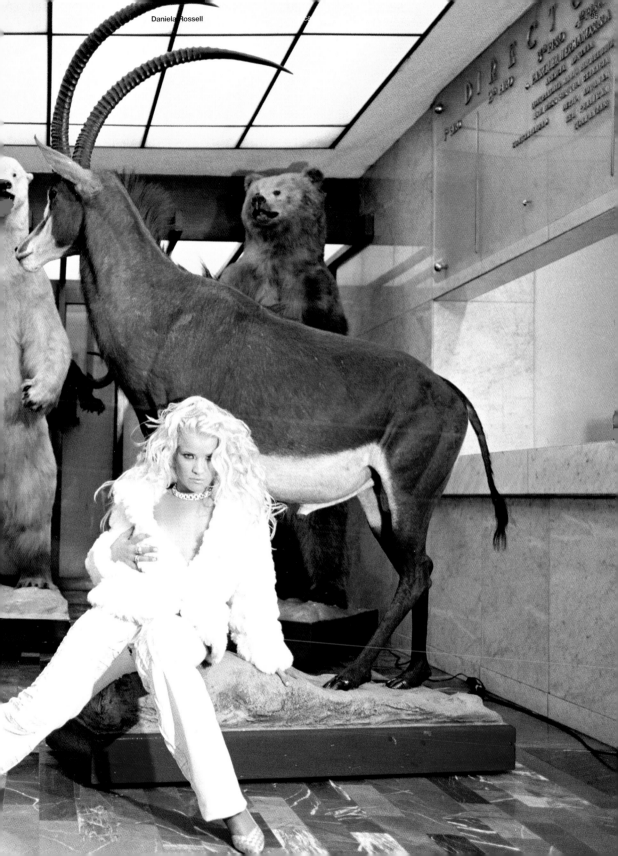

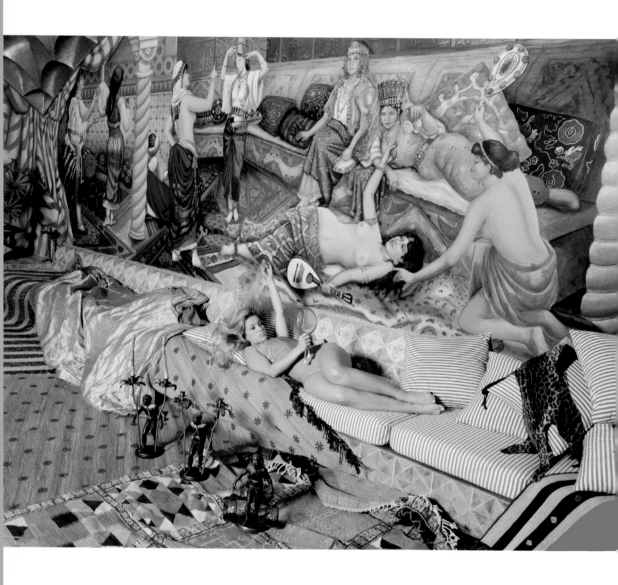

Selected Solo Exhibitions
2002
Galerie Peter Kilchmann, Zurich, Switzerland

Galería Enrique Guerrero, Mexico City, Mexico

2000
P.S.1 Contemporary Art Center, Long Island City,
New York

Selected Group Exhibitions
2001
ArtBasel 01 Stand Galería OMR, Basel, Switzerland

2000
Pervirtiendo el minimalismo, Museo de Arte Centro
Nacional Reina Sofía, Madrid, Spain

1998
Made in Mexico—Made in Venezuela, Art Metropol
Gallery, Toronto, Canada

Selected Bibliography
Anthony Huberman et al., *Mexico City: An Exhibition
About the Exchange Rates of Bodies and Values*, New
York: P.S.1 Contemporary Art Center, 2003.

Santiago Sierra, "A Thousand Words," *Artforum*,
October 2002.

Adriano Pedrosa, "Santiago Sierra. Museo de Arte
Contemporaneo Internacional Rufino Tamayo,"
Artforum, January 2000.

Santiago Sierra
Born in Madrid, Spain, 1966. Lives and works in Mexico City.

Estorbando en el periférico (Blocking the Freeway), 1998

Estrobáltico en el periférico (Blocking the Freeway), 1998

Selected Solo Exhibitions
2002
Six Steps towards Abstraction, Galerie Peter
Kilchmann, Zurich, Switzerland

2001
100% acrylic, Galeria OMR, Mexico City, Mexico

1997
Orange Lush, The Anglo, Mexico

Selected Group Exhibitions
2003
Mexico Attacks, Associazione per l'Arte
Contemporanea Prometeo, Lucca, Italy

2002
Sublime Artifical, La Capella, Barcelona, Spain

20 Million Mexicans Can't Be Wrong, South London
Gallery, London, England

Selected Bibliography
Anthony Huberman et al., *Mexico City: An Exhibition
About the Exchange Rates of Bodies and Values*. New
York: P.S.1 Contemporary Art Center, 2003.

Tom Crowley, "Mexico City on the Move," *Tema
Celeste*, May/June 2003.

Yehia Naief, "Mexico City: An Exhibition About the
Exchange Rate of Bodies and Values," *Art Nexus*,
October 2002.

Melanie Smith
Born in England, 1965. Lives and works in Mexico City.

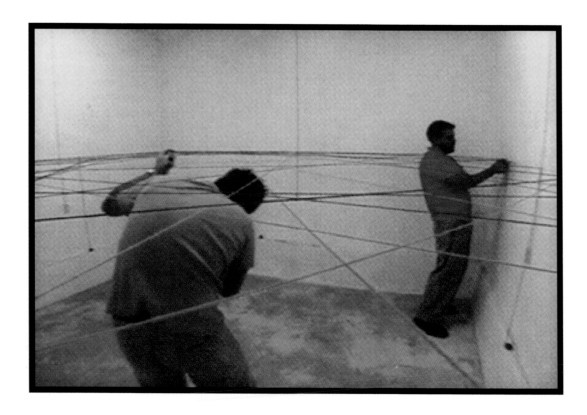

Selected Solo Exhibitions
2001/2
Anton Vidokle, Massimo Audiello, New York,
New York

1999
45/85, Massimo Audiello, New York, New York

Selected Group Exhibitions
2003
Utopia Stations Venice Biennale, Italy

Without You I Am Nothing, Platform Garanti
Contemporary Art Center, Istanbul, Turkey

Form-Specific, Moderna Galerija/Museum of
Modern Art, Ljubljana, Slovenia

2002
Urgent Painting, Musée d'Art Moderne de la
Ville de Paris, Paris, France

Selected Bibliography
Linda Nochlin, "Less Then More," *Artforum*,
September 2003.

Lauri Firstenberg, "Notes on Renewed
Appropriationisms," *Parkett* 67, 2003.

Anton Vidokle: Popular Geometries, essay by
Joshua Decter, TRANS Publications, 2001.

Anton Vidokle
Born in Moscow, Russia, 1965. Lives and works in New York City.

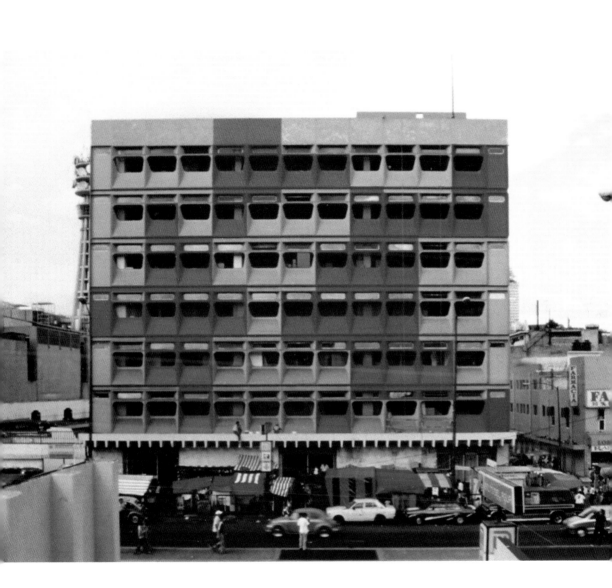

Pamela Echeverría

Interviews with 10 *Made in Mexico* Artists

An artist's particular view of the world is related to where in the world he or she works. My intention in undertaking these interview was to find aesthetic aspects that could distinguish and perhaps unify the diverse artists represented in Made in Mexico. To this end, each interview was structured around three basic questions that would initiate a dialogue on the idea of "making" in Mexico. The responses depended as much on the artist as on the type of work they produce. Yasumasa Morimura, for example, has never set foot in Mexico, while Mona Hatoum, who has worked on specific projects in Mexico, discussed the challenges faced by artisans in inventing solutions to creative problems. Claudia Fernández thought about the consequences of artistic freedom, while Anton Vidokle and Eduardo Abaroa both clearly articulated the circumstances that allow them to work in Mexico. The longest answers came from Pedro Reyes, Melanie Smith, and Sebastián Romo, who spoke about disorder and chaos. By contrast, Erik Göngrich offered his assessment of a certain order found within the historic center of Mexico City, while Francis Alÿs's impressions of the same neighborhood are centered around the paradox of mobility and stasis. In the end, the interviews reveal certain common practices as well the inevitable advantages and disadvantages of making art in Mexico.

I would like to sincerely thank all of the artists for their participation in this project.

Eduardo Abaroa (Mexico)

PE What is it like working in Mexico?

EA A mess.

PE What do you find in Mexico that you can't find anywhere else?

EA Family and friends. Low rent. Cheap materials and labor.

PE Is there a testimonial aspect to your work?

EA Yes, whether you want there to be or not, but I am not interested in emphasizing this aspect.

PE The fact that you mention materials, cheap labor and disorder already projects an idea of "making" things and of the resulting forms. I would like to ask what types of benefits or prejudices do these aspects bring to your work?

EA There are aspects of Mexico City that enable the physical production of sculpture, videos, paintings, etc. (Like I said: cheap labor, relatively cheap space compared to other large cities, easy transport.) There are others (like for example readily available books, good exhibitions, and access to technology at low prices) that are found more readily in the United States. In reality, the work of art is realized out of a negotiation between the characteristics of the context in which you work and your original ideas. For better or for worse, you have to take advantage of it. What bothers me most about working in Mexico is the difficulty in obtaining information in the form of books, etc. What I like most is that in general you are safe because you can survive with relatively little income.

Francis Alÿs (Belgium/Mexico)

PE What is it like working in Mexico?

FA Mexico fascinates me for its ambiguous affair with modernity, forever arousing it and at once forever delaying it.

PE What do you find in Mexico that you can't find anywhere else?

FA The truth is I don't know. I work where I am, here. I will ask myself the question once I find myself in another place.

PE Is there a testimonial aspect to your work?

FA I consider myself more of a documentarian. I wish I could pretend that the only personal advantage of having an immigrant status is a certain critical distance from my everyday reality.

PE Within your work there are elements that refer to mobility or movement, such as magnetic toys, dogs, automobiles, not to mention your "Walks." Do you think there exists a condition of movement particular to Mexico City?

FA On the one hand, Mexico City is extremely static due to its age, its history, and its being geographically enclosed within a ring of mountains. On the other hand the city as I know it, its historic center, is from nine in the morning until seven at night in a constant state of agitation from the omnipresent movement of street vendors. The irony being that the same movement generates, at the end of the day, a gangrene from the urban density that has paralyzed the entire zone.

Claudia Fernández (Mexico)

PE What is it like working in Mexico?

CF On the one hand, cultural context is very stimulating for making art – what you see, what you eat, what you smell, what you hear, etc. – which allows the possibility of maintaining a creative state that is alive and alert.

PE What do you find in Mexico that you can't find anywhere else?

CF Here there is a strong and very diverse cultural mix and there exists a freedom of movement and of action which one can take full advantage of if needed, but there is also a lot of suffering. A flexibility so great that it gives space to things and, although it sounds clichéd to say so, is at times surreal. At the same time as this malleable reality exists, it also prevents other practical processes.

PE Is there a testimonial aspect to your work?

CF Absolutely. In the first place, I make many different types of work, some that are more emotional and others that function on many different levels. One of these functions not only as an aesthetic proposal or abstract work, but also as an aesthetic investigation. For example, in the architectural series I have photographed hundreds of domestic facades that respond to the dominant panorama of hybrid architecture in many urban areas of Mexico. But on the other hand they function, due to the manipulation of the image, as abstract or minimalist works.

Eric Göngrich (Germany)

PE What was it like working in Mexico?

EG I think the photo and interview project I realized in Mexico City puts all subsequent city projects in perspective. I think of Mexico City as a single entity from the university campus (Uiversidad Nacional Autónoma de México) in the south, to Indios Verdes (with the Instituto Politécnico Nacional) in the north, and from the new office valley Santa Fe in the west to Ciudad Neza in the east. In other words, a city held together by the subway system and the specific order of a historical center that is surrounded by sub-centers. It seems that the Zocalo is like the lung of the city which is open for different uses (as well as a free circus where people line up), including the direct occupation of public space. Nobody questions the fact that there are hundreds of small stands that fill the streets selling everything from household goods to lemonade. The surrounding sub-center also includes parks like Chapultepec or wrestling-areas around the Coliseum. This directly understandable city-structure gave me the feeling of having known the place for a long time. Besides that I loved the "found aesthetics" in Mexico City. This could be anything from objects I encountered or installations in the streets or coming across a "Paris Hairdresser" on my way from the metro station to Diego Rivera's Anahuacalli museum.

PE What do you find in Mexico that you can't find anywhere else?

EG After working for one month in Los Angeles that is very clear: public transport + life with the street and a really good use of public space + Zocalo + La Merced + UNAM + El Pedregal + Espacio Escultórico + Diego Rivera´s museum/studio Anahuacalli + cantinas +…

PE Is there a testimonial aspect to your work?

EG I don't understand this question. Can you explain?

PE Testimony is a subjective interpretation or witnessing of events rather than an objective classification of information like in documentation.

EG The situations or objects in my photos demonstrate both the occurrence of an event through their randomness, but at the same time give an indication of future events. For me the order of the photographs questions their importance in relation to their surroundings. Consequently, these found installations can potentially be the basis for the deveopment of a public space.

Mona Hatoum (Palestine/England)

PE What is it like working in Mexico?

MH I found Mexico a very inspiring and exciting place to work in. I spent two one-month periods in Mexico producing work for solo exhibitions at Laboratorio Arte Alameda in Mexico City and the MACO (Museo de Arte Contemporáneo de Oaxaca), and both periods were extremely produc-tive, resulting in the making of several new works.

PE What do you find in Mexico that you can't find anywhere else?

MH Unlike my experience in the industrial world, I found that people in Mexico are very inventive when itcomes to making things. They often come up with ingenious solutions and are ready to try out anything and stretch the rules even when it concerns traditional crafts. I felt very at home with this preindustrial way of solving problems which echoed my own experience growing up in the Middle East.

PE Based on your experience, do you think an aesthetic common denominator exists in the production of craft within developing countries?

MH The common aesthetics I am interested in are those resulting from the recycling of materials and objects, the inventive low-tech solutions, the aesthetics of form-follows-function which produces its own poetics of the plain and simple or very colorful cheap versions of useful everyday objects. The inventive solutions are the result of necessity and lack of resources which is a common situation in developing countries.

Yasumasa Morimura (Japan)

PE What is it like working in Mexico?

YM I have never been to Mexico. I think it is more important for me as an artist to have imagina-tion than real experience. So I give priority to my imagination, which expands in my brain. For example, in my early works, like Portrait (La source 1, 2, 3) or Daughter of Art History (Theater A, B) which are based on La source by Ingres and Olympia by Manet, I had never seen these works before making my works. I remember that I was surprised to find there are many works I worked on in the collection of Musée d'Orsay in Paris when I visited later. It might be out of the question to have this attitude if I were a researcher of art history. However, as an artist, I think it is one of the mental techniques to keep my proper imaginary world without being disturbed with too much information.

PE What do you find in Mexico that you can't find anywhere else?

YM I am fascinated by the cultural situation in Mexico where many different elements from various cultures are mixed, which we can see in the ultra baroque. I like the chaotic situation in Mexico, which is not about confrontation but rather coexistence.

PE Is there a testimonial aspect to your work?

YM There is no testimonial aspect to my work. The testimony which seeks justice or truth is for the political, legal, or ideological world. Of course there is a case that the political, legal, or ideological subject is strongly related to art; however, art has another mission. It is to look at the world which is beyond everything, which we cannot prove with any testimony, where human actions and ideas are absurd. I think this is the world that artists should face, which cannot be covered with that of politics.

Pedro Reyes (Mexico)

PE What is it like working in Mexico?

PR I think for Earth, Mexico, and especially Mexico City, represents a midpoint between wealth and chaos, in other words between a state of well-being and a state of disaster. Seeing that this midpoint is my place of origin, whenever I travel to a supposedly first-world country making comparisons is inevitable. The United States, Europe, or Japan is a different experience, and that can indirectly offer information on Mexico City.

In the United States, I have the sensation, not of a society of consumption, but of a society of waste. For me it is inevitable to think that the level of abundance in the United States is a reflection of the shortages that are located beyond its borders, although it must be noted that China's surplus and the miracle of cities such as Shanghai is reflected not only in the impoverishment of the northern border of Mexico, but also in the manufacturing crisis of the central states of the American union. In Europe the state of well-being is prospective, and its abundance has not only been planned a while back but is also planned toward the future. I'm not mentioning this in order to talk about economics but rather because of certain feelings that flow through me, that I observe, and that I try to comment on here. In Europe, for whatever the generality of the term is worth, I feel more of a sense of lethargy that surges forth from the sudden disappearance of the friction that one is accustomed to in Mexico City. In Mexico you rebel as an everyday act of survival. In the United States you cannot rebel because any act even the slightest bit subversive can incur a mark on your passport, and in Europe there isn't a direct cause to rebel against, you're anesthetized.

PE Aesthetically, is there a midpoint between wealth and chaos?

PR There exists a concept in materialism called holistic ontology, which is basically the emergent properties of a system that constitute its particularities, its character. Holistic ontology is totality which is something and that something defines a totality. One of the most precise and undoubtedly most subjective forms to measure or determine a holistic ontology is precisely aesthetics. In other words, what is there to make profound on the surface. The immediate appearance of the context already gives an infinity of data. In Mexico's case it displays hybridity and a multiplicity of styles. In the industrialized countries one has the concept of the corporate image, of homogenization of chains. In Mexico instead of chains there are nebulas that hold together family businesses that being small-scale require other forms of publicity, basically sign painters, a custom that tends to disappear in inverse proportion to the wealth of a country. Sign painters have a calligraphic dimension and a pictorial richness that I enjoy enormously. Another heterogeneity you will find is in the use of industrial materials, facades, doors, roofs, pavements, for instance.

PE What things do you find here that you can't find anywhere else?

PR This is a city of crafts with a variety of small shops and masters. Mexico is an agglutinator of microbusinesses that is criticized on a macroeconomic level and on a grand scale reflects a diminished potential compared with the machinations of global industrialization; but it could be that on a creative level it may have another type of potential, which is basically one of flexibility, disposition, and inventiveness. For an artist this is an ideal context, especially if his or her work, as in my case, is related to the development of prototypes and manufacturing on a micro scale. In other words, in Mexico I can cross the street and on the same day I can have someone make or help me make a piece of ironwork, carpentry, hand-painted signs, electronics, woven plastic – seamstresses, cooks, pyrotechnic experts, automobile mechanics, ceramists, paper artisans,

musicians, basically any type of expert, whom I can work with without intermediaries, without contracts, without written permissions, without previous consultations, without any of the typical protocol needed for this type of labor to create works and which in other countries is costly and scarce. I don't want to exaggerate the privileges of working in Mexico, because there are others lacking, for instance punctuality and perfection are not the norm. But with this I would like to say that there are a series of factors that represent friction and fluidity, which leads me to begin to explain the aesthetic theory of corruption, which is a combination of an adhesive and a lubricant which at the same time brings along a new ethical system.

PE Does an aesthetic of corruption exist? Can you describe it?
PR Let's see, I would like to clarify something. I have some ideas about corruption that are not necessarily about aesthetics, although they can function within that realm. The idea came about in thinking about Joseph Beuys's thermal theory in which heat is represented as the manifestation of the fraternity and energy of a group. Perhaps that concept can function in a cold climate, but in a tropical climate other social contracts exist.

My hypothesis on corruption is that it has a double aesthetic function. On the one hand it's a lubricant (speeds up transactions) and on the other hand it's an adhesive (both the corruptor and the corrupted are bound together by complicity and by the condition that each respects the agreement and assures discretion). This combination of adhesive and lubricant enables a social contract of a strange, sticky consistency. These are the types of manifestations that need to be raised when analyzing a thermodynamic, social context. I believe that in the moment I was analyzing Beuys I realized that his principles couldn't be applied directly to this context, but rather it was necessary to update them or come up with new formulas.

PE Is there a testimonial aspect to your work?
PR I don't seek to reflect my milieu but instead transform it. My work projects the potential of a context, and from that perspective it seeks to expand creative capacities. This is a way of knowing myself by the pleasure produced through the work I do.

PE Is there a messianic question in between there? Something having to do with doing good?
PR Yes, positivism is part of the intention, because there exists a mysticism of work that functions not in order to be served but rather to serve, not to be understood but to understand, not to employ the universe but rather to become an instrument of it.

Sebastián Romo (Mexico)

PE What is it like working in Mexico?

SR Having access to numerous possibilities with highly qualified artisans, or better yet "ready and willing" with experience, and with the necessary openness to make almost anything. Unlike New York where you would probably have to find a specialized place where it most likely would be difficult to make a piece or a necessary element for the work within the appropriate time and budget.

Working in Mexico is being in contact with other forms of reality. It's to overcome many obstacles and to work in multiple social spectrums, with a pace, unusual customs, and budgets that could potentially drive any European crazy. For me this apparent disorganization connects diverse worlds which can coexist and which directly influence the strategies that are needed to make work.

PE What do you find in Mexico that you can't find anywhere else?

SR One of the most basic problems is the cultural and historical legacy and its diversity. In order to make "nationalist" art, or art with historical references, there is too much information, distorted, without classification, or totally alive and present. It is difficult to know where to begin and with what cultures, and which of all places we can refer to. An example of this would be if Anselm Kiefer, who painted so many epic portraits of Germany, had to do the same thing in Mexico. He would be confronted with diverse mythologies, with diverse pantheons, with diverse aesthetics and myths all presented in an archaeological manner; dead, for lack of total comprehension, and alive in usages and customs, in a city where fifty-four dialects and languages are still spoken. I say this in part because so many foreign artists find themselves in Mexico. Distance can permit points of engagment and discovery, on which they base their work and deploy their strategies. Henry Moore + Chac mool, Tina Modotti, Jackson Pollock = Siqueiros (Piroxilinas y acrílicos "Politec"), Anton Vidokle, Sergei Eisenstein, Luis Buñuel, Edward Weston, Francis Alÿs, Melanie Smith, Thomas Glassford, Santiago Sierra, Gropius in Monterrey, just to name a few. Not to mention all of those who are currently working with the Suro family ceramic workshop in Guadalajara.

In contrast to other countries where the "everday" is based in mass media, in Mexico the "everyday" can be recuperated and transfered to another context without having belonged to a publicity campaign or as an article of export for use in any place. Firsthand information, from the interior of situations. Endless sites and non-sites. In order to make any project, from working with cadavers to mounting exhibitions in markets, or simply not being in order to be.

PE Is there a testimonial aspect to your work?

SR Normally I create a set of rules which my work or series conforms to, and from there the formal or aesthetic result develops.

The process of construction of the piece selected for Made in Mexico changes with the manner in which words are chosen. The difference being that the piece based on Lower Manhattan was made in Brooklyn, in a studio overlooking the East River. The piece based on Mexico City was made from within the city, in my hometown, and during its construction, I asked all types of people, taxi drivers, collectors, intellectuals, friends, curators, domestic workers, etc., to give me between five and ten words which described Mexico City. These were then integrated into the different buildings which make up the piece.

I think one of the most important things in terms of what is known as the aesthetic of Mexican art, is the lack of a market. In contrast to New York, where for creativity to be branded, whether thematically, technically, or content-wise, is almost indispensable, in Mexico the lack of an art market has enabled us not to limit our formal possibilities and content. I believe that the majority of artists in Mexico use whatever medium best articulates the idea. In general, concepts are layered over a technical refinement or the exclusive use of one medium.

Melanie Smith (England/Mexico)
PE What is it like working in Mexico?
MS Conflictive, on a lot of levels, but in the end I think that's the base of the work. Visually, especially in Mexico City, your eyes never rest. There's a visual saturation that suggests chaos and permeates your psyche. If conflict can be described as a process, then Mexico is moving all the time. There is not really a sense of completion here. Projects can start and fail. Things always seem to be in a transitory state and there are not so many expectations, at all times the necessary is a basic impulse and you have to react to changing situations. This state of incompleteness allows you to respond to the unpredictable. I think the unpredictable is something positive as opposed to stagnancy, which is the overwhelming sensation I have with the West. It's just like a big rock which just will not move, in spite of how hard you push it.

PE What do you find in Mexico that you can't find anywhere else?
MS You mentioned last night that a lot of artists had mentioned that they could only find workshops and a cooperative spirit in Mexico. Initially I found this to be true, but after a while it wore off – it's synonymous for me right now with a visual attraction to Mexico, which is something I'm working away from. More though, Mexico represents a kind of nonconformism. Lifestyle becomes secondary to a necessity to survive, and this wipes away a lot of unnecessary rubbish and protocol that I don't have to conform to here.

Corruption: mordida (bribes), multas (fines), etc. lead to a different level of understanding of the way in which one conducts one's day to day existence. With this comes a new sense of complexity about law and enforcement, politics and social interaction, and at the same time a sense of tyranny and great repression. There is always a sense of the answer no never being no – todo se puede (anything's possible) – but at the same time you don't know where to find ground amongst such disorder.

PE Is there a testimonial aspect to your work?
MS I think there's an aspect of personal testimony in all artists' work, it's just the manner in which it's conveyed in a lot of cases. In one way the testimony has become shifted in me because of being dislodged from one country to another – I think there's always some kind of conflict in me between a perceived reality and a memorized reality, and hence this push and pull I have all the time between reality and abstraction. Straight documentation doesn't really interest me – there must be some further thread that takes you somewhere else. I think that personal testimony can also be collective testimony – although I dislike the kind of art that turns artists into some kind of crusader, or mixes sentiment with political correctness.

Anton Vidokle (Russia/US)

PE What is it like working in Mexico?

AV I suppose it is not very different from working anywhere else as a foreigner, in the sense that there is a language barrier which makes the simplest transaction an unpredictable adventure. There is also a lack of familiarity with unspoken local conventions and customs; then there is a strange sense that as you are working you are not really working but are on a sort of vacation, just because you are removed from your normal context. All this creates a slight displacement from which you can see your work and yourself a little bit more clearly; it can be very productive.

PE What do you find in Mexico that you can't find anywhere else?

AV Some of my interest has to do with political history peculiar to Mexico, a way in which on the one hand it is a capitalist society, America's neighbor, and on the other it has roots in a revolutionary past that is contemporary with the Russian revolution, with socialist sympathies which lasted through the early 1980s and can still be traced even now. This somehow results in a very complex ideological and visual language that is very interesting to me.

More specifically, probably the stickers I made for the Do It show in Mexico City – it's a very important piece for me and it probably would not have been possible outside of that context for a number of reasons. The stickers are based on corporate logos, so if I made this work in the United States or Europe it would have involved a rather uninteresting critique of multinational corporations, global economy, etc., which was already very well explored in the 1980s. Doing it in Mexico, and involving Mexican companies, somehow made it possible to bypass this discourse and work with other, more utopian aspects of the logotypes and the kind of a modernist, progressive universalism that is imbedded in them.

The other element is the kind of an openness that exists in Mexico in terms of perception or interaction with an artwork: as you know, at the Museo de Arte Carrillo Gil in Mexico City it was possible to just give out the stickers to the public and let people do with them as they wished, directly in the museum. And this worked very well with the audience: the stickers not only filled the museum but spilled out to the university campus, restaurants, bars, private apartments (yours for example) – so the piece really entered the city in a meaningful way. This type of openness is rare for both museums and audiences in the US or Europe.

The production is another aspect: in the US and to some degree in Europe it's very, very difficult to use industrial processes for small scale productions. Factories, printing plants, and industrial machines have been streamlined to be very efficient for manufacture of vast quantities of standardized commodities, but any deviation from this is very difficult and expensive. So when I was looking for a printing plant to produce the sticker insert for the Venice Biennale that has over 140 individual forms and images, no one but the print shop in Mexico City wanted to take the job. In other words, there is something to working in Mexico that allows me to work with ideas and situations that are kind of deadlocked in Europe and the US, and this is really, really important.

PE Is there a testimonial aspect to your work?

AV You know, I am kind of tired of testimonial-type work. Most artists are already very self-involved people as is, and with this Oprah-type sensibility you see everywhere these days it's like being around teenagers all the time. It's OK but just not very interesting.

pg

Eduardo Abaroa (Mexico)
Untitled, 2002
Drinking straws, dimensions variable
Collection of Kenneth L. Freed, Boston

24 *Ancient vs. Modern (Mastodon with Yellow Cupcakes)*, 2003
Fiberglass, 58 x 30 x 36 inches
Courtesy of Jack Tilton Gallery, New York
Photo courtesy of the artist and Jack Tilton Gallery, New York

Francis Alÿs (Belgium), Juan Garcia (Mexico),
Enrique Huerta (Mexico), Emilio Rivera (Mexico)
27 *The Liar, The Copy of the Liar (cat. 1)*, 1992-94
Mixed media installation
Oil on plywood, enamel on metal sheet,
Collection of the artist
Photo courtesy of the artist

Claudia Fernández (Mexico)
33 *La belleza oculta en la propiedad ajena (The Hidden
Beauty in Someone Else's Property)*, 2000
2 C-prints, 78.5 x 57 inches each
La Colección Jumex, Mexico City
Photo courtesy of the artist and La Colección Jumex, Mexico City

Andrea Fraser (US)
36 *Soldadera (Scenes from Un Banquete en Tetlapayac,
a film by Olivier Debroise)*, 2002
DVD projection
Courtesy of the artist and American Fine Arts Co., New York
Photo courtesy of the artist and American Fine Arts Co., New York

Thomas Glassford (US)
Aster 260 T8/3500K, from the Aster Series, 2002—3
Fluorescent lights, 8.5 feet diameter
Courtesy of the artist and Galería OMR, Mexico City

Aster 200 T8/4100K, from the Aster Series, 2002—3
Fluorescent lights, 6.5 feet diameter
Courtesy of the artist and Galería OMR, Mexico City

Aster 200 T8/3000K, from the Aster Series, 2002—3
Fluorescent lights, 6.5 feet diameter
Courtesy of the artist and Galería OMR, Mexico City

Aster 140 T8/ 3500K, from the Aster Series, 2002—3
Fluorescent lights, 4.5 feet diameter
Courtesy of the artist and Galería OMR, Mexico City

Erik Göngrich (Germany)
43 *Sentado en el extranjero (Sitting Abroad) vol. 5*, 2000-2004
Installation, dimensions variable
Courtesy of the artist
Photo courtesy of the artist

Terence Gower (Canada)
Functionalism, 2003-04
Mixed media, dimensions variable
Courtesy of the artist

49 *Sombrero*, 2002
6 x 8 feet x 2 inches
Rotulista: Enrique Huerta
Collection of Enrique Peñafiel, Mexico City
Photo by Amanda Holmes, courtesy of the artist

Andreas Gursky (Germany)
53 *Untitled XIII (Mexico)*, 2002
C-print mounted on Plexiglas in artist's frame, 109 x 81 inches
Collection of Jeanne and Michael Klein, Houston, Texas.
Photo courtesy of the artist and Matthew Marks Gallery, New York

Mona Hatoum (Palestine/Britain)
54 *El párajo de la suerte (Fortune-Telling Bird)*, 2002
DVD, 1:32 minutes
Courtesy of the artist and Alexander and Bonin, New York
Photo by Arturo González de Alba, courtesy of the artist

56 *Pom Pom City*, 2002
Natural wool, 2 x 141 inches; 12 feet diameter
Courtesy of the artist and Alexander and Bonin, New York
Photo by Arturo González de Alba, courtesy of the artist

58 *La jaula mexicana (The Mexican Cage)*, 2002
Wood, paint, and aluminum, 75 x 112.5 x 77 inches
Courtesy of the artist and Alexander and Bonin, New York
Photo by Arturo González de Alba, courtesy of the artist

Sharon Lockhart (US)
61 *Enrique Nava Enedina: Oaxacan Exhibit Hall, National Museum of
Anthropology, Mexico City, 1999*, 1999
3 C-prints, 49 x 61.5 x 2.25 inches each
Collection of Museum of Contemporary Art, Chicago, Partial gift of
George and Lori Bucciero
Photo courtesy of the artist and Blum & Poe, Los Angeles

Teresa Margolles (Mexico)
En el aire (In the Air), 2004
Bubble machine and bubbles made with water from the morgue,
dimensions variable
Courtesy of the artist

Lavado de autos (Car Wash), 2003-04
DVD
Courtesy of the artist and Galería Enrique Guerrero, Mexico City

Made in Mexico **Checklist**

69 **Yasumasa Morimura (Japan)**
An Inner Dialogue with Frida Kahlo (Hand-shaped Earring), 2001
Color photograph, 82.75 inches diameter
Courtesy the artist and Luhring Augustine, New York
Photo courtesy the artist and Luhring Augustine, New York

75 **Gabriel Orozco (Mexico)**
Black Kites, 1997
Human skull and graphite, 8.5 x 5 x 6.25 inches
Collection of the Philadelphia Museum of Art: Purchased with funds
contributed by the Committee on Twentieth Century Art
Photo by Graydon Wood, courtesy of the Philadelphia Museum
of Art

81 **Damián Ortega (Mexico)**
*Adentro/afuera (Superficie modulada) [Inside/Outside
(Modulated Surface)]*, 2002
Acrylic and glue, 16.5 x 45.5 inches
Collection of Kenneth L. Freed, Boston
Photo by Adam Reich, courtesy of the artist, D'Amelio Terras,
New York and kurimanzutto, Mexico City.

Pedro Reyes (Mexico)
Maquetas arquitectonicas, 2003
40 mixed-media sculptures, dimensions variable
Collection of Craig and Ivelin Robins, Miami Beach

89 **Sebastián Romo (Mexico)**
Limite, 2002–2003
Museum board on aluminum platform, dimensions variable
Courtesy of the artist and Galeria OMR, Mexico City
Photo courtesy of the artist and Galeria OMR, Mexico City

Daniela Rossell (Mexico)
Ricas y Famosas (Butterflies), 2002
C-prints, 30 x 40 inches
Courtesy of the artist and Greene Naftali, New York

93 *Ricas y Famosas (Last Supper)*, 2002
C-prints, 30 x 40 inches
Courtesy of the artist and Greene Naftali, New York
Photo courtesy of the artist and Greene Naftali, New York

94 *Ricas y Famosas (Janita Office)*, 2002
C-prints, 30 x 40 inches
Courtesy of the artist and Greene Naftali, New York
Photo courtesy of the artist and Greene Naftali, New York

96 *Ricas y Famosas (Arabesque Jana Harem)*, 2002
C-prints, 30 x 40 inches
Courtesy of the artist and Greene Naftali, New York
Photo courtesy of the artist and Greene Naftali, New York

99 **Santiago Sierra (Spain)**
Estorbando en el periferico (Blocking the Freeway), 1998
9 C-prints, 8 x 10 inches each
La Colección Jumex, Mexico City
Photo courtesy of the artist and La Colección Jumex, Mexico City

11 Persons Paid to Learn a Phrase, 2001
DVD, 12 minutes
La Colección Jumex, Mexico City

Melanie Smith (Britain)
102 *Installation of Paintings (variation) for Six Steps to Abstraction*, 2002
Acrylic enamel on acrylic/ MDF and aluminum
VHS tape, cassette players, and monitors
Dimensions variable
Courtesy of the artist and Galerie Peter Kilchmann, Zürich
Photo courtesy of the artist and Galerie Peter Kilchmann, Zürich

Anton Vidokle (US/Russia)
107 *Nuevo*, 2003
Original: 16mm film, transfer to digital video master. Duration 3:56
Cinematography and editing by Julieta Aranda,
sound by Christian Manzutto
Collection of the Jack S. Blanton Museum of Art, University of Texas
at Austin
Photo by Julieta Aranda, courtesy of the artist

Untitled, 2002
Digital print on canvas, 71.5 x 41.5 inches
Collection of Kenneth L. Freed, Boston

pg

Additional photo credits

23 Courtesy of the artist and Jack Tilton Gallery, New York
39 Courtesy of the artist
46 - 47 Photo by Fernando G. Rios, courtesy of the artist
50 Courtesy of the artist
64 Courtesy of the artist and Galeria Enrique Guerrero, Mexico City
65 Photo by Cuauhtemoc Medina
66 Courtesy of the artist and Galeria Enrique Guerrero, Mexico City
71 Courtesy of the artist and Luhring Augustine, New York
73 Courtesy of the artist and Luhring Augustine, New York
77 Photo by Adam Reich, courtesy of the artist, D'Amelio Terras, New
 York and kurimanzutto, Mexico City
78 - 79 Photo by Aaron Igler, Courtesy of the artist, D'Amelio Terras, New
 York and kurimanzutto, Mexico City
82 - 87 Courtesy of the artist
103 Courtesy of the artist and Galerie Peter Kilchmann, Zürich

Gilbert Vicario
Acknowledgements

I would like to extend my sincere appreciation to all of those individuals who helped with the conceptualization, organization, and planning of this exhibition. First of all I would like to thank Jill Medvedow, Director of the Institute of Contemporary Art, Boston, and former Chief Curator Jessica Morgan for their support and encouragement of this project, as well as Nicholas Baume, Chief Curator, for his keen eye for detail and dedication to the project. Likewise, Paul Bessire and Elizabeth Essner, my colleagues in External Relations, who worked tirelessly in securing funds for this exhibition; my curatorial colleagues Nora Donnelly, Tim Obetz, and Emily Moore, who provided incredible support, both moral and logistical; Melissa Kuronen, Communications Manager, who ensured that the exhibition reached Boston audiences; and Matthew Abbate, copy editor, for his assistance with the catalogue.

I am incredibly indebted to many individuals in Mexico City who assisted, advised, critiqued, and encouraged my research into current artistic practices in Mexico. First and foremost, Pamela Echeverría, Curator at the Museo de Arte Carrillo Gil, who provided immeasurable guidance, support, and friendship throughout the course of this project. I am grateful to Patricia Martin, Curator of La Colección Jumex, for her generosity and enthusiasm for the project; to Patricia Sloane, Director of Museo de Arte Carrillo Gil, for her intelligence, wit, and wisdom on cultural politics in Mexico; and to Ítala Schmelz, Director of Sala de Arte Publico Siqueiros, Victor Palacios, SAPS, Paloma Pòrraz Fraser, Director of Laboratorio Arte Alameda, Magda Carranza, Director of Patronato de Arte Contemporáneo, A.C. (Patrons of Contemporary Art), and Mariana Munguía Matute, Coordinator, Patronato de Arte Contemporáneo, A.C. (Patrons of Contemporary Art), for their enthusiasm and their assistance with key contacts in Mexico City. I also thank Bertha Cea Echenique, Senior Cultural Affairs Specialist, U.S.—Mexico Embassy, and Margarita Gómez Gamio, Taide Navarette Pellicer, and Eduardo de Olloqui of the Mexican Consulate in Boston.

Special thanks to all of the galleries, museums and individuals who generously loaned work to the exhibition, including Enrique Guerrero and Elizabeth Diaz of Galería Enrique Guerrero, Jamie Riestra and Montserrat Albores Gleason of Galería OMR, Rodrigo Peñafiel, Mexico City, Peter Kilchmann and Claudia Freidli of Galerie Peter Kilchmann, Zurich, Ted Bonin, Director of Alexander and Bonin Gallery, Danny McDonald of American Fine Arts, Co., Carol Greene of Greene Naftali Gallery, Victoria Cuthbert of Matthew Marks Gallery, Claudia Altman Siegel of Luhring Augustine Gallery, Jack Tilton of Tilton Kustera Gallery, Tiffany Chestler, curator of the Craig and Ivelin Robins Collection in Miami, Kanishka Raja of the Kenneth L. Freed Collection, Lucia Álvarez and Michel Blancsubé of La Colección Jumex, Domonic Molon of the Museum of Contemporary Art, Chicago, Michael Taylor of the Philadelphia Museum of Art, and Gabriel Perez-Barreiro of the Jack S. Blanton Museum of Art at the University of Texas, Austin.

Finally, I would like to thank all of the artists in *Made in Mexico* for their creativity and singular vision.

Catalogue for Made in Mexico, an exhibition held at the
Institute of Contemporary Art, Boston January 21 – May 9, 2004
UCLA Hammer Museum, Los Angeles June 6 – September 12, 2004

Major support for the exhibition has been provided by Altria Group.

Additional support has been provided by the National
Endowment for the Arts, Kenneth L. Freed, and La Colección Jumex.

Special thanks to the Mexican Consulate in Boston/S.R.E.

Distributed by D.A.P., Distributed Art Publishers, Inc.
155 Avenue of the Americas, Second Floor
New York, NY 10013-1507, USA
Phone 212 627 1999
Fax 212 627 9484

ISBN 0-910663-66-1

Curator/Editor: Gilbert Vicario
Curatorial Assistant: Emily Moore
Registrar: Nora Donnelly
Copy Editor: Matthew Abbate
Design by FDTdesign, New York
Printing by Eurografica, Italy

The Institute of Contemporary Art
955 Boylston Street
Boston, MA 02115, USA
Phone 617 266 5152
Fax 617 266 4021
www.icaboston.org